# THE *STEP-BY-STEP*
# PHOTOGRAPHY
# WORKSHOP

**More than 50 illustrated techniques for improving your work**

*Adam Jones*

**WRITER'S DIGEST BOOKS**

CINCINNATI, OHIO
WWW.WRITERSDIGEST.COM

*To my wife Sherrie*
*for her unwavering support*
*and understanding.*

Visit our Web site at www.writersdigest.com for more information and resources for writers.

Other fine Writer's Digest Books are available from your local bookstore or direct from the publisher.

08  07  06  05  04          5  4  3  2  1

Cataloging-in-Publication data is available from the Library of Congress at <http://catalog.loc.gov>.

ISBN    1-58297-216-8

Editor: Jerry Jackson, Jr.
Designer: Barb Matulionis
Design Supervisor: Clare Finney
Production Coordinator: Robin J. Richie

## ACKNOWLEDGMENTS

Success is never achieved alone and I've had the good fortune of sharing ideas and learning from some of the most talented photographers in the business. I'm especially grateful to William Manning for his friendship and allowing me to lead tours for Nature's Light where we've shared incredible adventures around the globe. I'm forever indebted to Marv Dembinsky for sharing his wealth of business knowledge and for gently guiding the early days of my budding career. Special thanks go to talented friends Danny Dempster, Tony Sweet, Arthur Morris, Darrell Gulin, Ian Adams, Dennis Flaherty, and Stan Osolinski for their friendship and inspiration.

## ABOUT THE AUTHOR

Adam Jones has been a full time nature, wildlife, and travel photographer for the last 10 years and has quickly risen to the top of his profession. His photos have been used for packaging, advertising, and editorial layouts in more than 30 countries. His photographs appear in publications from National Geographic, National Wildlife Federation, World Wildlife Fund, Time, Life, People, Disney, Eddie Bauer, Ford Motor Company, Sierra Club, Audubon, and Hallmark Cards.

In 1995 Adam won the "In Praise of Plants" category in the prestigious Wildlife Photographer of the Year competition. Currently Adam is represented by eight stock agencies worldwide including Getty Images. He is also on the Photographers' Advisory Board at Natural Selection Stock Photography, Inc.

Adam has been leading domestic and international photography tours for a decade with Nature's Light and a variety of other organizations. He is also a highly regarded member of Popular Photography's Mentor Team. Anyone interested in travelling with Adam, or organizations wishing to schedule a photographic workshop, tour, or speaking engagement can obtain information from his website at www.adamjonesphoto.com or e-mail at adamjonesphoto@insightbb.com.

# Contents

# EQUIPMENT

## LENSES

In simplest terms, photographic lenses form images. Lenses are classified by focal length, which is the distance from the optical center of a lens focused at infinity to the film plane where the image is formed. This distance is expressed in millimeters. The enormous diversity of lenses ranging from 6mm ultra-wide fisheyes to 1200mm super telephotos has much to do with the popularity of 35mm SLR cameras.

Having a view similar to what we see, a 50mm lens is considered the standard or normal lens for 35mm photography. Subjects are neither enlarged or reduced; they're normal. As focal length gets smaller the angle of view encompassed by the lens becomes greater. Ultra-wide angle lenses (16–20mm) have very short focal lengths and a very wide angle of view, capturing huge amounts of territory. Beginners often select wide-angle lenses to record grand mountain vistas only to be disappointed with the results. What happened? A wide-angle lens reduces towering mountains to distant bumps. From any given point, a wide-angle lens reduces image size. From any given point a telephoto lens increases image size. From a fixed position, a 100mm lens will produce an image on film that is twice as big as a 50mm lens. A 500mm telephoto produces an image ten times larger than a 50mm lens.

So what lenses should you buy? Let the subject matter you enjoy photographing dictate the lenses you buy. Lenses in the 500mm to 600mm ranges are common for wildlife photography, while much shorter and less expensive lenses are ideal for landscapes. The optical quality of zooms has improved to the point of being indistinguishable from single focal length lenses. For precise framing, zooms allow unmatched flexibility. This is especially true for moving subjects. When building your system, consider high-quality zooms for your everyday workhorse lenses. A few specialty lenses such as a macro or super-telephoto can round out your system. As a basic outfit, consider two zooms: a 28-135mm and a 100-400mm. These two zooms will easily cover 90 percent of most enthusiasts' requirements. As your needs grow, add an ultra-wide 16-35mm zoom or a 500-600mm fixed telephoto and you will be equipped like a pro.

You get what you pay for when buying lenses. Buy the best lenses available and you'll only buy them once. In terms of maximum aperture, buy the faster lens. It's optically better, the viewfinder is brighter, and higher speed lenses work much better in low light. Lenses with designations like LD (Low Dispersion), ED (Extra Low Dispersion), and UD (Ultra Low Dispersion) are of the highest quality and the most expensive. Autofocus has improved to the point where I consider it essential for nearly every lens. State of the art autofocus systems make tracking fast moving subjects almost routine. Even so, look for lenses that allow you to instantly override the autofocus for a quick manual tweak of the focus.

At the time of this writing, professional grade image stabilized lenses are available from Canon and Nikon. These lenses feature internal mechanisms that actively move lens elements inside the lens barrel to help minimize camera shake associated with handholding. This feature reduces the shutter speeds normally required for sharp images by as many two to three stops. Canon's latest generation image-stabilized lenses also work on a tripod to greatly reduce the effects of mirror slap.

Another highly desirable feature is internal focus. Lenses of this design move lens elements inside the lens barrel to achieve focus. This allows for a smaller and lighter

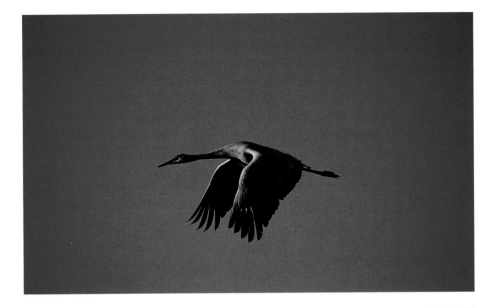

**This type of action photo** is where autofocus really excels. In this shot I turned off all but one autofocus sensor, thus ensuring focus on the eye and not on the wings or body. From a Wimberley Sidekick, I panned with the bird's flight path, keeping the AF sensor on the head and neck area.

**Sandhill Crane in flight at first light**

Bosque del Apache National Wildlife Refuge, New Mexico
Canon 500mm image stabilized lens, at F4, 1/125 sec.
Kodak E100VS pushed 1 stop

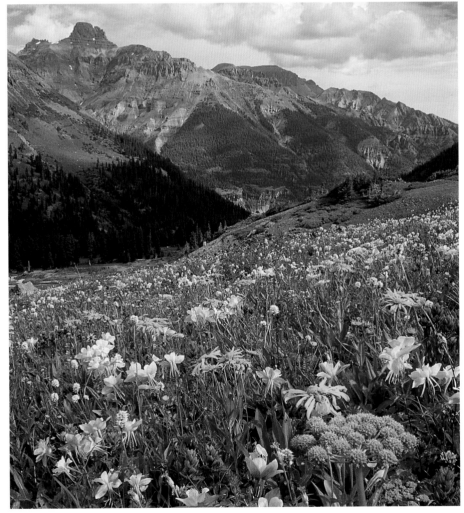

**Just out of the picture**, a large rock pile greatly restricted where I could set my tripod. Setting up in the only spot possible, a wide-angle zoom lens provided the right focal length for a pleasing composition. In the field, zoom lenses prove to be an invaluable tool for cropping to the desired composition.

**Wildflower Meadow. San Juan Mountains, CO**

Canon 17-34mm zoom near 24mm, F22, 1/8 sec. Fuji Velvia

weight lens that focuses much closer than noninternal focus designs. Even more important is that light isn't lost as the lens is focused from infinity to its closest focus point. Since the lens barrel doesn't rotate, using a polarizing filter is much less aggravating.

If you own Canon cameras, buy Canon lenses. If you own Nikon cameras, buy Nikon lenses. This way you'll have a complete system where everything is designed to work together with the fewest compromises. Yes, the lenses are a bit more expensive, but you'll get the highest optical quality and most durable lenses from the major camera manufacturers.

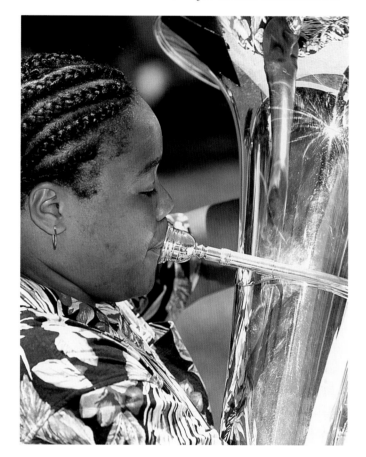

**In this illustration** an image-stabilized zoom saves the day. The crowded conditions ruled out using a tripod and I couldn't move any closer to my subject. A 100-400 IS zoom lens set at 400mm provided the reach and image stabilization assured tack sharp handheld images. Without IS, this shot would be nearly impossible.

Musician, Great American Brass Band Festival, Danville, KY

Canon 100-400mm image stabilized lens, near 400mm setting, F8, 1/250 sec. Fuji Provia

## CAMERAS

In basic terms a camera is just a box that holds and advances the film. However, modern cameras have evolved into sophisticated machines offering incredible performance with models priced to fit every budget. As a working pro, I need a rugged full-featured body such as the Canon EOS-1V. When starting out, carefully consider which features most suit your requirements. Always buy the best you can afford, but keep in mind that a camera body with all the bells and whistles isn't useful without a good selection of quality lenses. Good lens selection offers greater opportunity to explore your creativity than expensive full-featured camera bodies.

What should you look for in a camera body? First and foremost it should be a single lens reflex design that accepts a full line of interchangeable lenses. When deciding on a brand, make sure the manufacturer offers a full line of innovative consumer and professional grade lenses. It's very frustrating and expensive to find yourself switching brands after outgrowing a particular system. Currently, Canon and Nikon are most widely used by professionals, but other pros are perfectly happy making a living with Pentax, Minolta, and Olympus systems.

Nearly every modern camera features TTL (through-the-lens metering), which means the camera meters light actually passing through the lens. This eliminates the need to figure exposure compensations every time you add an accessory such as filters, teleconverters, and extension tubes. A well-designed camera should offer several automatic exposure modes, especially aperture priority mode. This means you select an aperture and the camera automatically sets the correct shutter speed. Be wary of models that don't allow you to override the automatic exposure by simply turning a dial or thumb wheel. Overriding the automatic exposure should not involve using both hands, nor should you be required to remove your eye from the viewfinder. A completely manual mode is also a must. There are situations when manually setting the aperture and the shutter speed is highly desirable.

Mirror lock up allows the user to lock the cameras reflex mirror in the up position. This eliminates all vibration caused by the mirror flying up and slapping inside the camera. This is especially useful for macro and telephoto applications where even the slightest vibration degrades image quality.

A depth of field preview button is an essential feature that is often left off many otherwise good cameras. Activating this device allows you to preview the image in the viewfinder at the aperture selected for use. I consider this a must-have feature.

For any kind of action shooting autofocus is a must. Canon and Nikon really excel in this area with both companies offering state of the art autofocus systems. A built-in motor drive works hand in hand with autofocus, adding many more keepers to action sequences.

A 100 percent viewfinder is nice, but in many cases a bit overrated. Think about it; you only see about 95 percent of the slide once its mounted in cardboard mounts. Cameras should also have user-programmable functions for setting vital functions to your preferred method of operation.

A spot meter is another must-have feature. This feature reduces the area metered to a small well-defined area in the viewfinder, allowing you to meter selective areas in a scene and set exposure accordingly. As far as I'm concerned, a built-in spot meter is a must-have feature.

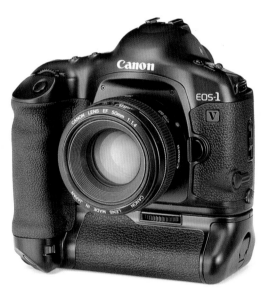

**Shown here** is Canon 's flagship film camera built for all weather ruggedness and loaded with advanced pro features. This workhorse is highly recommended if it fits your budget. If you're on a tight budget or in the early stages of building your system, consider less expensive bodies, and put your money into lenses first.

Canon EOS-1V with high-speed power booster attached

**Shown here** is a less expensive camera body, with many desirable features for considerably less cost than higher-end SLR bodies.

Canon EOS Elan 7

## FILTERS

It seems there is no limit to the number of trick filters on the market. Most are gimmicky and of limited usefulness, however, certain filters I never leave home without. One of the most useful is a polarizing filter. This is used to remove unwanted reflections and to increase saturation. It is commonly used to saturate and darken blue skies. Twist the polarizer and white puffy clouds dramatically pop against a darkened blue sky. Maximum polarization is achieved when your lens is aimed 90° to the sun. The polarizing effect diminishes as you aim toward the direction of the sun or directly away from the sun. A polarizer can be used with just about any focal length, but use caution when polarizing skies with wide-angle lenses. Wide-angle lenses see such

a wide view that only a portion of the sky is polarized, creating an uneven looking image. Polarizing filters are not just for sunny days, they also remove shine from wet rocks, water, and vegetation even in the dreariest light. See the images on page 13.

When the sun isn't shining, warming filters can save the day. On cloudy days, warm wavelengths of light are filtered out resulting in light that is bluish and cold. Warming filters help restore color balance and prevent color slides from recording too blue. They are commonly available in the following designations from weakest to strongest: 81A, 81B, 81C, 81EF. I commonly use an 81A for slight warming of slide films in overcast light. An 81B is slightly stronger if you want more warmth. When shooting in open shade on a

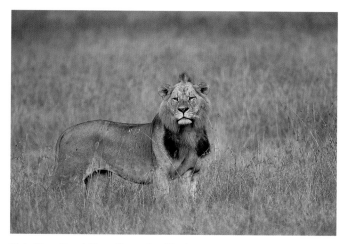

Male Lion, Masai Mara, Kenya (no filter)

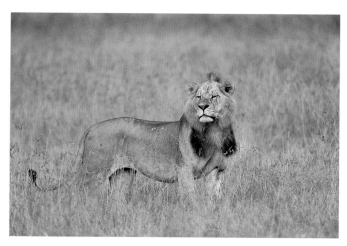

Male Lion, Masai Mara, Kenya (warming filter)

**In the left image** I photographed a male lion on a cloudy morning with no warming filter. The color rendition is decent, but a bit blue/green for my taste. In the second shot above I added an 81A warming filter. The color in the second image is clearly warmer and more pleasing.

---

**Male Lion, Masai Mara, Kenya**

Canon 500mm IS lens, at F4, 1/30 sec. No warming filter, Fuji Velvia

**Male Lion, Masai Mara, Kenya**

Canon 500mm IS lens, at F4, 1/30 sec. With an 81A warming filter, Fuji Velvi.

blue-sky sunny day, you'll need an 81EF filter to correct for this extremely blue condition. If needed, warming filters can be stacked with a polarizing filter.

Another must-have item is a graduated neutral density filter. These are square or rectangular filters designed to slide up or down in a holder in front of your lens. The top half of this filter is shaded in various densities of neutral gray while the lower half is clear. The filter is positioned in front of the lens so the shaded area selectively holds back exposure where needed. These filters are sold in strengths of one, two, and three stops. A 2-stop graduated neutral density filter reduces exposure 2 stops wherever the shaded portion of the filter is placed in a scene and has no effect on the rest of the image. Tiffen, Lee, and Hoya make these filters; some

of the best are made by Singh-Ray. I suggest buying a 1 and 2 stop to start and adding a 3 stop filter later.

An unusual filter worth considering is a Blue/Gold Polarizer. This special polarizer does not remove reflections. In fact, it will add blue or gold color to specular highlights as the polarizer is turned. This filter ads extra punch to morning and afternoon light. Use this filter with great caution, it can be overpowering in many situations. This filter requires a good deal of trial and error to get accustomed to its peculiar characteristics and to learn when and where to use it. Singh-Ray makes an excellent threaded blue/gold polarizer. See page 12.

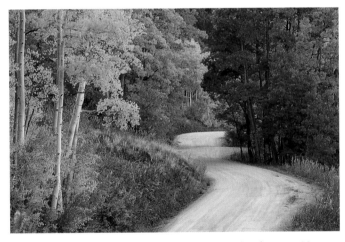

**Forest road in open shade (no filter), Gunnison National Forest, CO**

**Forest road in open shade (warming filter), Gunnison National Forest, CO**

**This rural scene** above was photographed in the open shade of a mountain on a clear sunny day with blue sky overhead. The first road scene without a warming filter is extremely blue and dreadful. In the second version an 81EF warming filter greatly improved the overall color balance.

**Forest road in open shade, Gunnison National Forest, CO.**
Canon 100-400mm IS lens, at F16, 1 sec. No warming filter, Fuji Velvia

**Forest road in open shade, Gunnison National Forest, CO.**
Canon 100-400mm IS lens, at F16, 2 sec. With an 81EF warming filter, Fuji Velvia

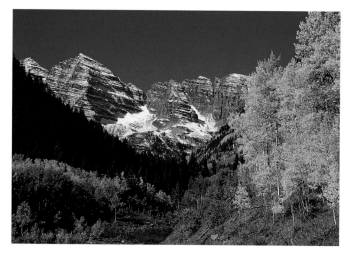

Maroon Bells (polarizer), White River National Forest, CO

**These reflection images below** illustrate the solution to a common exposure problem where the top part of a scene is illuminated 2 stops brighter than the lower part. Color slide film can't properly record an exposure difference this large. The solution is to hold back the exposure on the sunlit upper half of the image with a 2-stop graduated neutral density filter. With the filter in place, the upper half of the image is brought into balance and both areas can be exposed properly.

**Top Photo: Millcreek Lake at sunrise, KY**

Canon 17-35mm lens, F16, 1/2 sec. Without graduated neutral density filter. Velvia

**Bottom Photo: Millcreek Lake at sunrise, KY**

Canon 17-35mm lens, F16, 2 sec. With Singh-Ray 2-stop Graduated Neutral Density Filter. Velvia

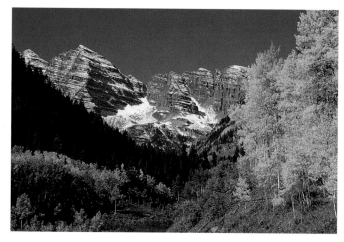

Maroon Bells (blue/gold polarizer), White River National Forest, CO

Millcreek Lake at sunrise, K. (No filter used.)

**The above set of images** from Maroon Bells shows the difference between a regular polarizer and a blue/gold polarizer. The regular polarizer looks fine and the colors are very normal in appearance. The blue/gold version is much warmer and the yellow aspen leaves are dramatically improved. The blue/gold version is more dramatic, but the overall color cast of the sky won't please everyone.

**Top Photo: Maroon Bells, White River National Forest, CO**

Canon 28-135mm IS lens, F16, 1/30 sec. Regular Polarizer, Kodak E100VS

**Bottom Photo: Maroon Bells, White River National Forest, CO**

Canon 28-135mm IS lens, F16, 1/20 sec. Blue/Gold Polarizer, Kodak E100VS

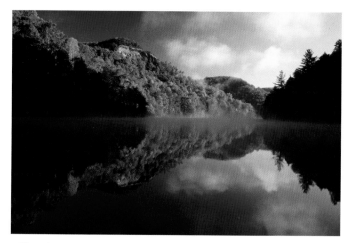

Millcreek Lake at sunrise, KY (ND filter used.)

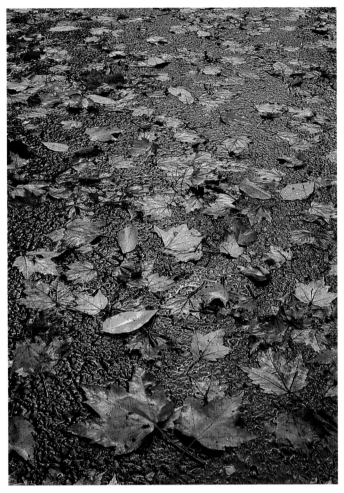

**Autumn leaves on rainy day (no filter)**

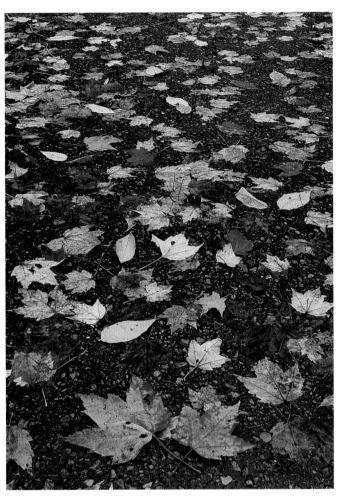

**Autumn leaves on rainy day (polarizer)**

**This set of images** shows the usefulness of a polarizing filter even on rainy days. Color and contrast is very weak in the top, nonpolarized version. In the second image the polarizer added a great deal of contrast and color to the leaves and pavement. Clearly, a polarizer is a useful on cloudy rainy days.

**Autumn leaves on rainy day.**

Canon 17-35mm lens, F16, 1 sec. No polarizing filter, Kodak E100-VS

**Autumn leaves on rainy day.**

Canon 17-35mm lens, F16, 4 sec. With regular polarizing filter, Kodak E-100VS

## TRIPODS & HEADS

When starting out most photographers' give little thought to supporting their equipment, however, a quality tripod, head and quick release system is essential to every nature photographer. Why pay for high quality optics if you're happy with less than critically sharp handheld images? A tripod is the only piece of equipment you can buy that immediately improves your photography. In addition to vastly improving sharpness, a tripod also lets you study your composition. Quality tripods and heads are usually sold separately, which enables the discerning photographer to tailor an outfit around his/her needs. Avoid buying a cheap ultra-light tripod. They inevitably prove inadequate and you end up purchasing another.

Purchase the right tripod first and you'll only have to buy one. I've used one Gitzo 320 tripod for twenty years. A tripod should accommodate shooting at your eye level without extending the center column. This basic requirement eliminates most of the ultra-light designs. A short tripod forces you to work bent over, which soon becomes tiring and uncomfortable. When considering a tripod at the dealer, keep in mind that a tripod is effectively shorter when set up on a slope. If weight is a real concern and cost is not, consider a carbon fiber tripod. Carbon fiber designs are very rigid and much lighter than comparable metal tripods. In cold weather, the composite material doesn't absorb heat from your hands like metal. Another must have feature is a provision for spreading the legs to reach subjects at ground

level. Many tripods are supplied with a long centerpost that totally defeats getting close to the ground. Either cut the long post off, or purchase a separate short center column. Don't believe for a minute that you'll invert the center column and work between the legs.

A good tripod head complements a tripod and makes it a joy to use. Cheap heads with small poorly designed quick release systems won't support your equipment properly and are a nuisance in the field. Your first decision is whether to go with a pan tilt head or a ball head. A good pan head has three knobs for independently adjusting the horizontal, vertical, and panning movements. This design lets you loosen the head and make very precise adjustments to one axis without affecting the other two. Some photographers like working with three knobs and some despise this type arrangement. Do not buy a pan tilt head with only two movements! With this configuration, you're stuck loosening the camera screw or adjusting the tripod legs to recompose.

Ball head designs feature a single captive ball allowing the camera to be rotated in just about any position and locking tight with a single knob or lever. Ball heads are easier to operate when tracking a moving subject, however, balancing a heavy telephoto lens on this type head is very tiring. The rig is top heavy and tends to flop over to the side when the ball is loose enough for smooth tracking. Consider a ball head with at least a two-inch diameter ball, anything smaller is insufficient. A larger ball accommodates heavier equipment and operates smoother when under slight tension. A good

**A quality tripod** should possess three important traits: First, it should be tall enough to work at your eye level without raising the center column. Secondly, the legs should spread for working at ground level. Last but not least, look for a strong durable model that provides rock steady support in any position. The Gitzo 320 shown here easily meets these requirements and is obviously adaptable for setting up on awkward terrain.

**Gitzo 320 tripod working low to the ground on uneven terrain**

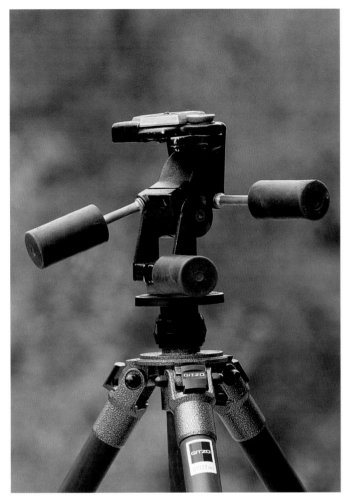

**Bogen 3047 three-way pan tilt head**

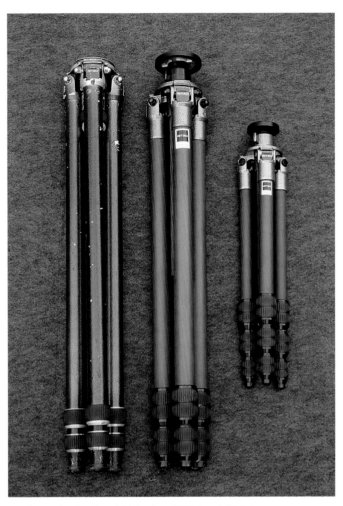

**My three tripods: Gitzo 320 Studex, G1327, and G1128**

**This Bogen 3047 head** is a great starting point when looking for a solid inexpensive three-way pan tilt head. This head does require Bogen's proprietary hexagonal plate #3049 for attaching your cameras and lenses to the head.

**My daily workhorse tripod** is a metal Gitzo 320 Studex. This particular model has served me flawlessly for over twenty years in every imaginable environment. I also use a carbon fiber Gitzo #G1327 with nearly the same specifications as my Gitzo 320 minus a few pounds of weight. This lightweight sturdy tripod is used for long hikes, cold weather shooting, and when traveling where weight restrictions are of concern. My Gitzo #G1128 is also carbon fiber design that collapses into a tiny lightweight package suitable for traveling. This little tripod is surprisingly steady, but not tall enough for my daily use, but it's excellent in crowded urban areas where a large tripod can be difficult to lug around and set up. If you must have a tiny lightweight tripod, the little Gitzo #G1128 is hard to beat.

quick release system puts the finishing touches on either style head. Quick release plates provide a rapid and secure method of attaching cameras and collared lenses to your tripod head. They eliminate the tedious task of screwing the camera on and off each time you set up.

A good basic starting point is an inexpensive Bogen 3021 tripod and Bogen 3047 head. The head is supplied with one hexagonal quick release plate #3049 that works quite well. See illustrations for additional suggestions.

## FILM

Photography is often referred to as painting with light; thus film is our canvas. At the time of this writing, the most widely used film in the world is 35mm color print film, but digital capture is rapidly catching up. Color negative films have been and continue to be popular in point-and-shoot cameras where exposure isn't critical. Negatives 1 stop underexposed to 2 stops overexposed still yield decent prints. Amateurs switching from print film to digital are surprised when discovering that accurate exposure is more critical than with print film.

I only use color slide films referred to as transparencies, designed for projection or viewing on a lightbox. Transparencies offer the advantage of extremely sharp images and rich saturated color, but demand very precise exposure. When exposure isn't nearly perfect, the image on a slide is ruined. Why would anyone shoot film that requires such precise exposure? Editors reviewing work for publication can see exactly what is recorded on slide film. Nearly every photo published in magazines, calendars, posters, and books originated as a color slide.

I can't look at a negative and judge image quality; furthermore, judging quality from an automated printer is even more absurd. Once an automated machine prints a negative, it's nearly impossible to differentiate your controls from those made by the machine. If you're really serious about learning the craft of photography, switch to color slide film. Perfect your skills just like a pro by ruthlessly evaluating your slides on a lightbox. Every success and every mistake is plainly visible. What better way to learn about photography? What you see on the slide is exactly what you shot.

I always prefer using the finest-grained film that does the job to high standards. So which slide films are best?

Until recently, I used a variety of sharp fine-grained films ranging from ISO 50-100 for nearly all my work. At the time of this writing my workhorse films are Kodak E100VS, Fuji Velvia 100F, and Provia 100F. Fuji's Velvia 50, favored for its warm highly saturated colors, superb sharpness, and very fine grain, has been the gold standard for nature photographers and photo buyers around the world. However, during the summer of 2003 Fuji introduced a new ISO 100 Velvia. Like Velvia 50, Velvia 100F offers high saturation and grain structure better than its slower cousin. Aside from the extra speed, the new film has several advantages. This new film requires less filtration under fluorescent lighting, but don't mistakenly think this means no filtration is needed. The new film also needs less filtration when shooting in open shade and skin tones are much improved. For most slide films, I recommendation an 81EF warming filter in open shade, however, Velvia 100F only needs an 81A or 81B. With all these improvements at twice the film speed, the competition will surely be scratching their heads once again. Now that Velvia 100F is available, I see little reason to shoot with Velvia 50. The extra speed is nearly always an advantage in the field.

Both Velvia films are particularly good at reproducing green foliage where high saturation and reproduction of subtle tones is important. Now with Velvia 100F, moving subjects are less of a problem and skin tones are not excessively warm. Today we're not forced to choose between slow saturated films and faster grainy films. Now, we simply choose a film with the color palette that suits our taste.

Fuji designed Provia to be neutral in color and extremely fine-grained. In fact, this film has one of the finest grain structures of any color slide film at the time of this writing. So why not use this film for everything? Provia's grain structure is indeed spectacular, but for nature work, I find the color flat and bluish unless corrected with heavy warming filters. When photographing people, accurate skin tones are usually very desirable. Both Kodak and Fuji make excellent films for this type work. Fuji's Provia 100F, Kodak's E100G, and E100GX are all wonderfully accurate, extremely fine-grained, and excellent choices for pleasing skin tones. Kodak's E100GX provides slightly warmer skin tone characteristics.

Also at ISO 100, Kodak designed E100VS to be highly saturated and very sharp to compete against Fuji's Velvia

50. Even though Fuji's Velvia matches VS on speed with even finer grain structure, E100VS is still an excellent film for use under a wide variety of situations. When accurate skin tones are important, don't use E100VS, it simply is too red. Each of these films is excellent, yet each possesses a different color palette. Experiment with each film and learn when to use each film's unique characteristics to your advantage. Kodak's E100VS has a definite red bias, while both of Fuji's Velvia films exhibit a mild blue/green bias. Neither is right or wrong, just different under various lighting situations.

It's impossible to illustrate how these films react under every possible condition. The light is constantly changing in the field. See comparison on page 18 to see how each film handles overcast and sunny situations differently. Realize any comparison represents a narrow range of conditions and other results are quite possible in the field.

My suggestion is to shoot several films side by side in as many different situations as possible and pick the one you like best. Use the slowest, finest grained film that will get the job done. Remember, as film speed goes up much beyond ISO 100, grain increases, color saturation is reduced and quality generally goes down. So go easy on the high-speed films (ISO 200-1600) unless absolutely necessary. Slow- and medium-speed films are wonderful, but sooner or later you'll find the need for even more film speed.

## PUSH PROCESSING

I'm often asked what to do when a higher film speed is needed. Even with fast lenses, there are times when 100 speed films are too slow. Instead of buying a 200-speed film, I "push" an ISO 100 film to 200. So just what is pushing film? Let's say I just loaded an ISO 100 film into my camera. Before taking any pictures on this roll, I manually set the camera to ISO 200. Be sure automatic DX coding is switched off. This new ISO setting underexposes the film by one stop, so I instruct my photo lab to over develop the film to compensate for the resulting underexposure. Note: I've found that a little extra pushing is usually required to get a true 1-stop push. Have your lab push process test rolls at 1 stop, $1^1/_4$ stops, $1^1/_2$ stops, $1^3/_4$ stops and simply pick the best processing time as your 1-stop push. I make it a habit to mark all pushed film before it goes into the camera. If I wait

until the roll is finished, there is a chance of removing the film from the camera and dropping it into a pocket among my normally rated film. Doing so leaves me feeling sick! Don't start pushing film in the middle of the roll or any previous shots will be overexposed.

For people and event shooting, I push nearly all my 100 speed films. In doing so, I have an excellent 200-speed film with accurate skin tones and tight grain pattern. Pushing Kodak's E100VS is my secret weapon when extra speed and eye popping color is desired for nature work. This film becomes warmer and highly saturated when pushed. Pushed VS is great for wildlife, macro shots, or any time the color really needs to pop. Once this film is pushed it no longer needs any kind of warming filter, even on very gloomy days! (See comparisons on page 19) Avoid pushing VS the first and last hour of a sunny day. During this time, sunlight is already very warm so pushing VS is not recommended. As a last resort, I use Provia 400F either normally or pushed a stop. Once again I'm not pleased with the color of this film, but in an emergency it may be the only solution. For an ISO 400 film, the grain is quite good, but a bit grainy when pushed.

While leading tours and workshops, I'm frequently questioned about keeping professional film cool while in the field. That's easy, I don't. I make no special attempt to keep film cool even during extended shoots in desert heat. The film can take the heat better than I can. Be sensible: Don't leave film inside a parked car in the hot sun for a week; otherwise don't worry about your film in hot conditions. Usually the trunk is much cooler than inside your car. In over 20 years I've never had a problem. Carrying film on commercial airlines and x-ray is another area of concern. Do not ship film in your checked baggage under any circumstances. Current x-ray machines used to inspect carry-on baggage do not harm film. Today, with the tight security at airports I no longer ask to have film hand checked. It's simply a big hassle. I've had film x-rayed as many as 8 times during extended international travels with no ill effects on film up to ISO 400. Relax, enjoy your trip and stop worrying about your carry-on film getting x-rayed.

**These three images** were exposed on a bright overcast day where I commonly use a polarizer and 81A warming filter. Each film clearly handled the overcast lighting differently. In the top image (Velvia) the ferns are rich and saturated and the green leaves in the background trees are as well. Note the slight green cast in the white aspen trunks. In the middle image (VS) the ferns are equally saturated and the green in the background trees nearly as good. However, note the white trunks of the aspen trees are cleaner and green cast is absent. In the bottom image (Provia) the ferns are dull, flat, and lifeless. The aspen trunks are not vibrant and again a slight green cast is evident.

**Conclusion:** I prefer the Kodak VS for its saturated color and accurate whites. Velvia is a close second. The Provia proved disappointing in overcast situations! That said, Velvia remains my favorite for sunny conditions.

---

**Aspen trunks, Kebler Pass, CO (Overcast Comparison)**

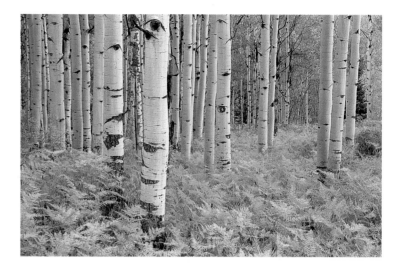

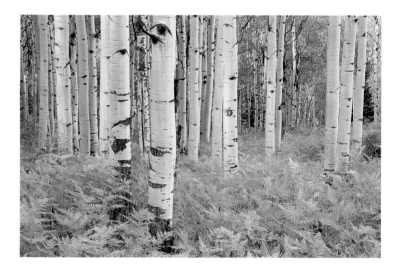

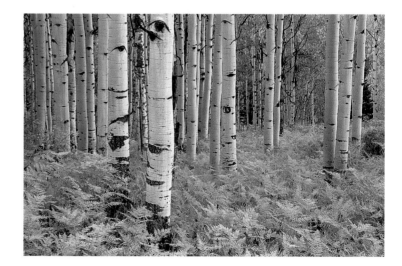

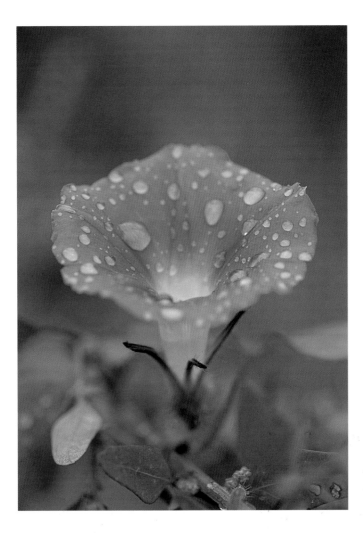 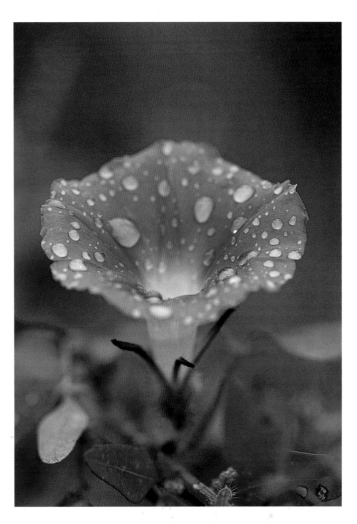

**In this comparison** both films were pushed 1-stop. In the left image, Velvia was exposed with an 81A-warming filter, my standard setup for overcast light. The results are excellent in all regards. In the right image VS was exposed exactly the same but without a warming filter. In this version the VS is even more saturated in the flower and in the green foliage. Clearly each film responds differently to push processing. Both are excellent; choose the one you prefer.

**Morning Glory Flower (Velvia/VS-Pushed Comparison)**

## MOTOR DRIVES

Most cameras today have a built in motor drive advancing the film at a decent rate of three to four frames per second. This is perfectly adequate for most normal shooting situations, but switch your camera to a tracking mode and the built-in drive slows considerably. When photographing sports or wildlife, an accessory high-speed motor drive is essential. Some high-end cameras are sold with high-speed motors that aren't removable. This design leaves you carrying a large, heavy camera and motor all the time. I prefer the option of choosing when to add a booster. With an optional booster, most cameras achieve film advance rates around seven to ten frames per second, which is plenty fast for most action situations.

A good motor drive should include a shutter button for use in a vertical position. This allows for a less tiring position for your hand when shooting verticals. A drive should also include buttons or dials for controlling the major camera functions while in a vertical shooting position. Images won't be lost while fumbling with the cameras main controls in a vertical position.

Most drives can be powered by a variety of batteries. Widely available AA alkaline batteries are the most commonly used. Other options include rechargeable NiCads and Nickel Metal Hydride batteries. When attached, most boosters supply all the power for the camera. A booster's larger power supply improves cold weather performance for cameras powered by lithium batteries notorious for poor cold weather performance.

A good optional drive ensures you are always ready for the next shot, but it doesn't guarantee dynamic action images. It takes great skill to consistently record good action shots. When subjects are moving quickly, even the fastest motor drive often fails to capture the peak moment. Sports and wildlife photographers learn to anticipate the action and know when to depress the shutter for quick burst. Capturing peak moments in action sequences is a learned skill enhanced by a good motor drive. See below.

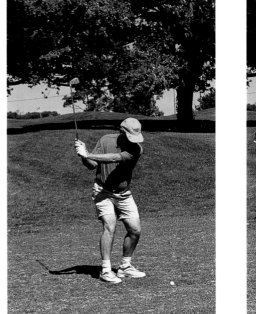 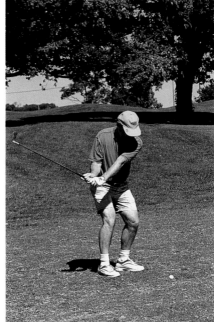 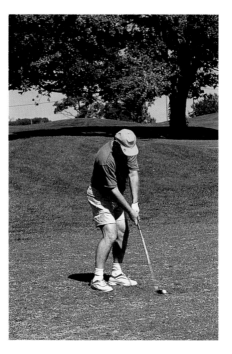

## TELECONVERTERS

Fifteen years ago I considered teleconverters junk and used them only as a last resort. Today these small optical magnifiers are dramatically improved and capable of delivering high-quality professional images. These optical wonders multiply the size of the image produced by a lens, effectively multiplying the lens focal length. Let's say you have a 300mm F4 lens and you attach a 1.4X teleconverter. Now you have a 420mm lens with an aperture of F5.6. Attach a 2X teleconverter to the same lens and you have the equivalent of a 600mm F8 lens.

Magnification increases with teleconverters, but you lose light when using them. A 1.4X costs you 1 stop of light; a 2X reduces light by 2 stops. Losing light works against you in the field because telephoto lenses are very shutter-speed sensitive, adding a teleconverter only worsens the problem. Along with magnifying the image, teleconverters also magnify lens defects. Even the best teleconverter degrades lens quality. The best teleconverters are expensive, and produced by your camera manufacturer. The very best 1.4X degrades resolution roughly 10 percent and a 2X about 20 percent.

It's not as bad as it sounds, if you pay attention to the following: Use teleconverters only with the very best optics. High-end professional grade lenses can afford to lose 10 to 20 percent of their resolution and still deliver exceptional results. Inexpensive consumer grade lenses usually don't fare as well. Limit yourself to a 1.4X teleconverter when possible. Even on the best lens, a 2X is pushing the limit. Stopping the lens down a bit can improve image quality.

Resist trying to make an average-length lens into a long telephoto. If you always need more focal length, buy a longer prime lens. Then use the teleconverters to make a long prime lens into a super-telephoto. You'll be much happier with the results. Be careful using teleconverters on zooms. Some zooms work fine and others are dismal. Again stick with a 1.4X converter. Use the absolute best technique possible. Focusing is critical and vibration problems are

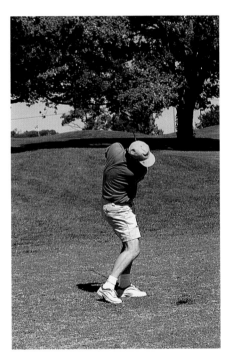 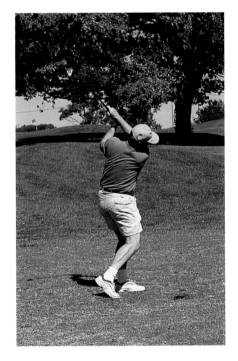

**This action sequence** at approximately eight frames per second illustrates a high-speed motor drive in action. My goal was to capture the golf club striking the ball. Notice how far the golf club moves between each frame. In less than a second the entire swing is complete. Even at eight frames per second, large gaps appear in the sequence. This sequence was repeated four times before capturing the club impacting the ball.

**Golf swing**
Canon 28-135mm IS lens, F8, 1/1000 sec. Provia pushed 1 stop

magnified. Use an image-stabilized lens if possible. Slower shutter speeds can be used with image-stabilized lenses. Most cameras won't autofocus with lenses slower than F5.6. Keep this in mind if you plan on using a teleconverter with a relatively slow lens. Canon's EOS-3 and EOS 1-V do autofocus with lenses as slow as F8.

I'm not trying to scare you with all these suggestions. In fact, I don't hesitate to use a 1.4X or 2X teleconverter on my Canon 500 F4 IS lens or my Canon 180mm macro lens. Both are capable of superb results with either converter at any aperture. In a pinch, I've even stacked both teleconverters together and produced publishable images.

**We had maneuvered** our vehicle as close as physically possible. Yet, a 500mm lens was too short for a tight close-up. Adding a 2X teleconverter enabled me to get this dramatic portrait with outstanding sharpness.

Canon 500mm IS lens, at F4, 1/250 sec, with 2X teleconverter, Velvia pushed 1 stop

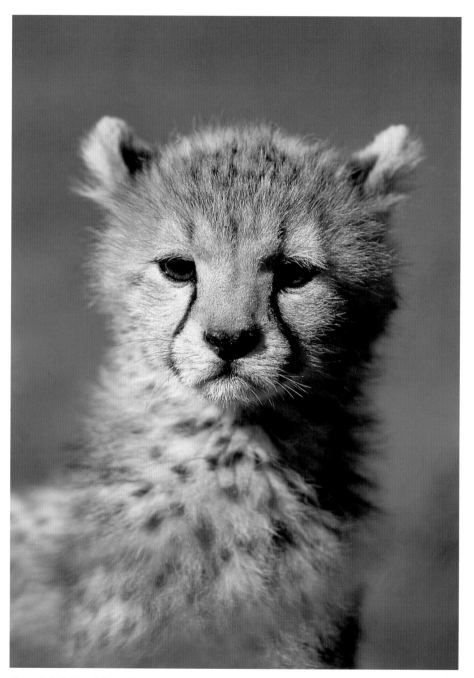

**Cheetah Cub, Masai Mara, Kenya**

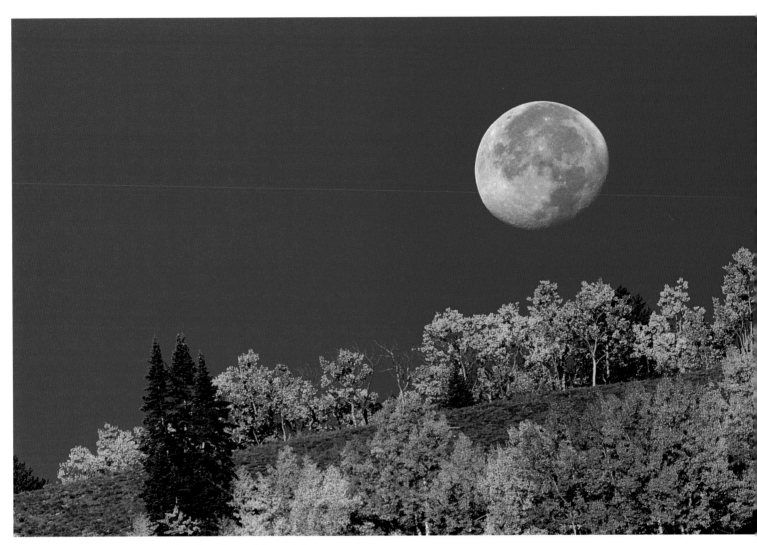

**Moon setting over autumn aspens, Gunnison National Forest, CO**

**Long telephoto lenses** are not just for wildlife. I wanted the moon to be large so a 1.4X teleconverter was added to a 500mm lens. Even though the trees are ¹/₄ mile away, I stopped down to F16 to ensure adequate depth of field for the moon and trees.

Canon 500mm IS lens, at F11, 1/125 sec. with 1.4X teleconverter, E100VS pushed 1 stop

## MY GEAR

Much of the success of 35mm photography stems from its great flexibility and convenience. There is a tool and accessory for every application. What you enjoy photographing largely dictates the equipment needed. Don't rush out and purchase a complete outfit in the beginning. Once you've been shooting for a while you'll better understand your needs and interests. Give yourself time to become familiar with every aspect of the gear you presently own. Learn what it can and can't do.

As a generalist, I don't specialize in one area of nature photography. As a result, my equipment needs are fairly broad. My lenses cover a range of possibilities from high magnification close-up, to wide-angle scenic, and wildlife. What I'm using today may not be what I'm using tomorrow. Five years ago I never dreamed my 70-200mm F2.8 lens would play second fiddle to a longer and slower zoom. With an extended zoom range and image stabilization, a 100-400mm IS lens is now my favorite mid- to long-range zoom. For me, the convenience of a zoom range that doesn't require teleconverters to reach 400mm outweighs the speed advantage of the shorter 70-200mm lens. Nikon owners can enjoy a similar 80-400mm lens with vibration reduction technology.

Always buy the best quality you can afford and balance your lust for new equipment against what you really need on a regular basis. Choose your gear wisely; the tools of the trade are quite expensive. When on location, I normally carry the following equipment in one Lowepro Photo Trekker AW backpack that is airline legal on full size airliners.

Three tilt/dhift (24mm, 45mm, and 90mm) lenses round out my collection of lenses. These special optics are usually packed separately and carried as needed.

One medium sized bag accommodates the lenses and accessories to cover a range from 15mm Fisheye to 1000mm super telephoto. In short, I'm equipped for any opportunity. As a hobbyist, do you need all this? Not necessarily! For tremendous versatility without breaking the bank, consider two zooms, one in the range of 28-135mm and another zoom around 100-400mm. These two zooms handle about 80 percent of my normal day-to-day shooting, and they'll likely do the same for you. For nature and outdoor photography, buy a backpack style camera bag. This style bag offers better balance, protection, and comfort

| Lenses: |
| --- |
| 15mm fisheye |
| 17-35mm |
| 28-135mm IS |
| 100-400mm IS |
| 500mm IS |
| 180 mmmacro |

| Accessories: |
| --- |
| 81A, 81B, 81EF warming filters, polarizing filter |
| 1.4X & 2X teleconverters |
| 1, 2, and 3 stop Graduated ND Filters (Singh-Ray) |

| Extension Tubes |
| --- |
| Flash 550 EX + off camera cord |
| (2) electronic camera releases |
| (10-20) rolls of film |
| Spare batteries for camera/flash |

| Cameras: |
| --- |
| EOS-3 |
| EOS 1V + motor drive |

when carrying your gear for long distances and over rough terrain. When working from my car, a huge Lowepro Super Trekker AW provides even more room for flash brackets and 24mm, 45mm, and 90mm tilt/shift lenses. However, once this large bag is fully loaded, it's difficult to carry. My smallest bag is a Nature Trekker AW with internal dimensions of 11.5" wide x 6" deep x 16.75" tall. Don't buy a smaller backpack, you'll need the extra room as your collection of equipment grows.

Last, but not least, I never leave home without a tripod. See tripods and heads on page 14.

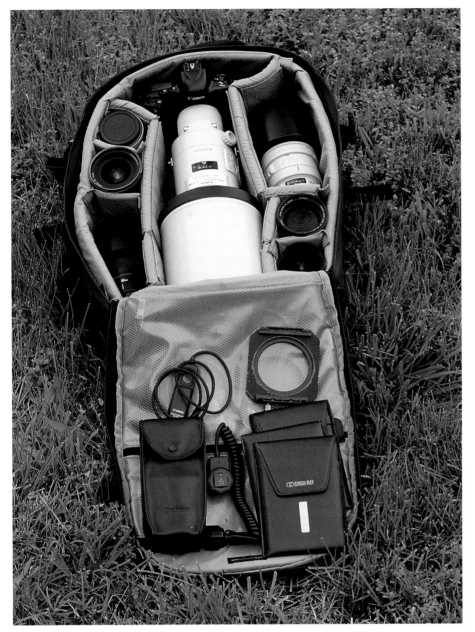

**What I carry in the field**

**Pictured here** is a medium-sized Lowepro Photo Trekker AW loaded with the gear I normally carry into the field. Shown is the following: 500mm F4 IS, 100-400mm IS, 28-135mm IS, 15mm fisheye, 180mm macro, 17-35, 1.4 X + 2X stacked together, Camera body, flash, off camera flash cord, electronic cable release, 1-, 2-, and 3-stop neutral density filters and holder. Film goes in the back flap.

# EXPOSURE

## UNDERSTANDING HOW YOUR METER WORKS

Let's take a look at how your meter really works. It may come as a surprise to learn your fancy camera only gives correct exposure from middle-toned or average-toned subjects. Meter a lighter or darker tone and you'll need to make some exposure adjustment. Middle tone is neither light nor dark. On a scale from very dark to very light, middle tone is in the middle. Color isn't important, the relative lightness and darkness of the metered area is what matters. Once your meter is calibrated (see page 30), simply shoot at the meter's recommended exposure for middle-toned subjects.

Let's begin by looking at the series of exposures on page 27. The first set is from middle-toned caladium foliage. Shown here is a first exposure at 0 compensation and variations in full stops above and below the original reading. At 0 compensation the exposure is dead perfect. By opening up (allowing the shutter to stay open longer) the exposure gets lighter. By closing down (increasing the shutter speed) the exposure gets darker. Working in stops above and below the initial reading, the foliage can be any tone from nearly black to almost white. In a nutshell, this is how exposure is controlled.

So far so good, but what happens when metering subjects lighter or darker than average? In the next shots of black velvet, it's clear the initial exposure without compensation renders the dark velvet as average. This is precisely how all camera meters work. Think of your meter as the great average maker. Regardless of the tone your meter is reading, the meter makes it average. The first exposure on the velvet at 0 compensation proves this. The exposure is indeed average, but it needs to be darker than average. To correct this, light must be subtracted when metering dark subjects. Subtract 1 stop of light and the image is dark gray. Subtract 2 stops of light and the velvet is extremely dark, just as it really appeared.

Very light tone subjects require compensation in the opposite direction. See page 29. In this winter scene, I spot metered the snow and again made an initial exposure at 0 compensation. Guess what? The very light-toned snow also recorded as middle-toned gray. To get a tone much lighter than average, more light must be added to the exposure. Depending on your preference, snow requires about $1\frac{1}{2}$ to 2 stops of extra light to be correctly exposed. Add 1 stop and the snow is light gray in tone. Add 2 stops and the snow is correctly exposed as a very light tone. Of course you won't always make full-stop adjustments. With a bit of experience you'll find that $\frac{1}{2}$ stop and $\frac{1}{3}$ stop adjustments allow finer exposure control. With this basic understanding of how your meter works, you should be able to meter any single tone and make the necessary compensation for the exposure you want.

-2

-1

0

+1

+2

**This average-toned** foliage needs no exposure compensation for correct exposure. Varying exposure in stops above and below average lets you control the tonality of your exposures. Notice how the shutter speeds change with the exposure compensations.

**Caladium foliage**

Canon 28-135mm IS, at F16, -2, -1, 0, +1, +2 stops compensation, E-100VS

-2

-1

0

+1

**This series illustrates** the compensations necessary to properly record dark tones. At 0 compensation, this very dark subject is once again exposed as average. When metering a dark tone, subtract light for correct exposure. This extremely dark subject requires -2 stops of exposure compensation for correct tonality.

**Black velvet**

Canon 180mm macro at F16, -2, -1, 0, +1, +2 stops compensation, Velvia

+2

-2

-1

0

+1

+2

**This set** of images illustrates how your meter incorrectly handles light tones. At 0 compensation, the snow is again exposed as average. When metering light-toned subjects, add light for correct exposure. Snow requires about +1¹/₂ to +2 stops of additional exposure for correct tonality.

**Cabin in winter, Brown County State Park, IN**

Canon 17-35mm lens, at F16, -2, -1, 0, +1, +2 stops compensation, Velvia

## CALIBRATING YOUR CAMERA METER

Today modern SLR cameras are fairly well calibrated at the factory for correct exposure. Even so, I still encounter photo enthusiasts on my tours and workshops with camera meters in dire need of calibration. The solution is simple; calibrate the meter yourself.

Many methods have been suggested for calibrating camera meters to a known value. For example: a clear north sky on a sunny day, "the sunny 16 rule" and Kodak gray cards. These methods can work, but conditions must be exactly perfect. First off, where exactly in the sky should I be pointing my camera? The sunny 16 rule assumes the day we choose to calibrate our meter is really a perfect sunny day: dead clear and low humidity. Those east of the Mississippi River know those kind of days are few and far between. Gray cards are notorious for giving false readings due to slight differences in how the card is positioned. Fortunately there is an easier more reliable method for calibrating your meter.

Camera meters are designed to expose accurately when aimed at a middle-toned subject—that is, a subject neither very light nor very dark. The natural world offers plenty middle-toned or average subjects suitable for calibrating camera meters. Green grass and many types of foliage are perfect for calibrating your camera. Select a subject that best represents how you want your middle-toned "average" subjects to be exposed. Select a subject of a single tone, with even lighting, and no shadows. When calibrating your meter using a noninternal focus lens, be sure the lens is focused at or near infinity. For most lenses, stop down about 1 stop from maximum aperture when running an exposure test. Most lenses exhibit some amount of light falloff when using the maximum aperture, which results in slight underexposure, and you don't want that figured into your calibration.

The examples of redwood sorrel on page 31 illustrate how exposing an average toned subject at various ISO settings can help us fine-tune our camera's meter. For this test I used Kodak E100VS. This film is rated at ISO 100, therefore my first exposure was made at F8 with the camera set at ISO 100. From a tripod, I made a series of exposures changing only the ISO settings on the camera. A complete set of exposures was then made at the following ISO settings: 64-80-100-125-160. Once the film is processed, lay it out on a good lightbox and simply pick the exposure you like best. Do not use a projector for evaluating exposure of your test slides. With this particular camera body this film, I prefer the exposure at ISO 80. This is a judgement based on my personal taste. Excellent results could also be obtained at ISO 64 and 100. The point is that I am now certain that this body is exposing the way I want when set at ISO 80 for E100VS. This process should be repeated for each camera and film you plan to use. Don't be alarmed if your mega-buck camera doesn't give the best exposure at the so called correct ISO. I don't bother sending cameras back for factory calibration. I simply adjust each camera to the ISO that gives me proper exposure. The number selected on the ISO dial is meaningless as long as you're getting proper exposure. This simple test procedure is a vital first step in gaining precise control of exposure. Calibrating your camera has nothing to do with pushing film speeds so your lab doesn't need to be informed of your new calibration.

**Most current SLR cameras** are equipped with built-in light meters, but not all light meters are properly calibrated. The solution may be as simple as selecting a new ISO setting.

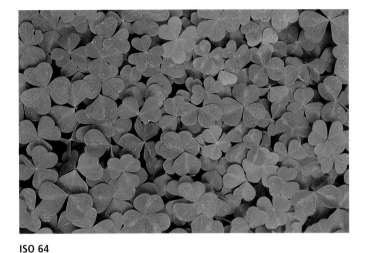

**ISO 64**

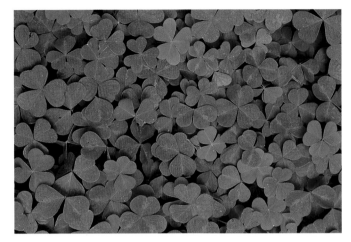

**ISO 80**

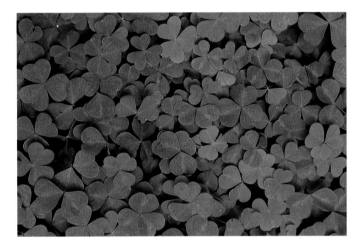

**ISO 100**

**ISO 125**

**ISO 160**

**This series** of exposures made at ISO 64, 80, 100, 125, and 160 demonstrate a reliable method of calibrating your camera's meter. The first image is slightly underexposed at the recommended setting of ISO 100. In my opinion the best exposure for E100VS in this camera is at ISO 80. I simply set my ISO dial to 80 and never give it another thought while exposing normally. Don't be surprised if your camera is even further out of calibration.

**Redwood sorrel, Redwoods National Park, CA**

Canon 180mm macro lens, F8, E100VS

## HOW EXPOSURE AFFECTS MOOD

For most subjects we strive for technically perfect exposures because slide film has a very narrow range of acceptable exposure. Once correct exposure is determined, there is little room to experiment with exposure. However, in some special situations there is no correct exposure and you should experiment.

When the light is subtle and diffused you can't trust your camera to expose precisely the way you want. The delicate ethereal quality of light just before sunrise and atmospheric conditions such as fog can be exposed over a range of acceptable exposures. You should bracket your exposures to match the precise mood you want. Opening up a stop from the indicated exposure will emphasize the light airy qualities of the image. Closing down a stop darkens the scene toward a more somber mood. I start with the indicated exposure and then bracket about a stop above and a stop under. This allows me to choose the precise mood I want back home on a lightbox. If you only make one exposure then you only have one choice. I'm not suggesting you bracket wildly in the hope of getting one good exposure, but to take control of the exposure and know what the outcome will be.

The images on this page illustrate clearly how exposure affects mood. All three exposures work, but they each have a different mood.

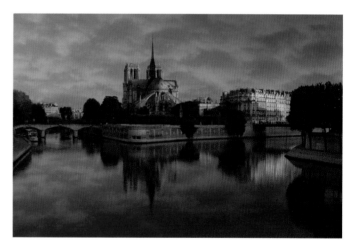

+1

0

**This series demonstrates** the way exposure effects mood. My first exposure was 0 compensation. I simply spot-metered the red clouds using no exposure compensation; the clouds are average, and the mood is neutral (not brighter or darker than they appeared). In image +1, I overexposed one stop from the metered reading and now the image is brighter with an open airy feel. In image -1 I underexposed 1 stop from the metered reading and the image has a heavier somber mood. Which is correct? Actually, all three exposures are useable; it really depends on which mood you wish to convey.

**Notre Dame at sunrise, Paris, France.**

Canon 28-135IS, F16, at +1, 0, -1 compensations, Velvia

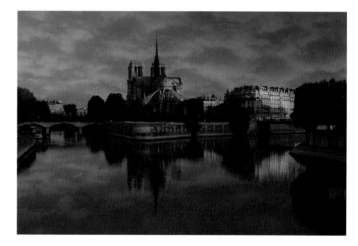

-1

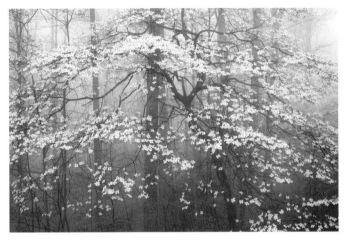

+1

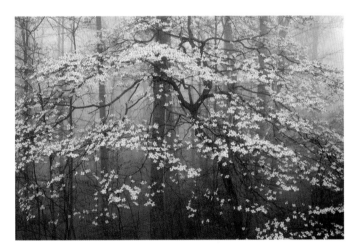

0

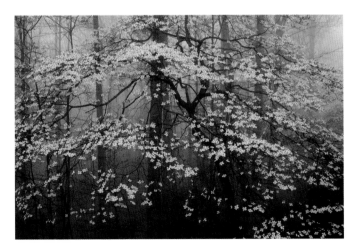

-1

**This series clearly demonstrates** how exposure affects the mood of delicate diffused light. My first exposure was 0 compensation, based on a spot-meter reading of the white blossoms near the top $1/3$ of the frame. Opening up $1^1/_2$ stops from the metered reading ensured the nearly white blossoms were recorded as a light tone. This was my base exposure, recording the mood just the way it really appeared. At +1 compensation, the brighter exposure emphasizes the delicate mist thus enhancing the ethereal qualities of the scene. At -1 compensation, the light, airy feeling is reduced to a heavy, somber mood. All three exposures are correct, yet each image has a different mood or feel. I suggest trying several exposure brackets for this kind of scene, so you'll have several exposure choices at home on the lightbox.

**Flowering dogwood in Foggy Forest, Great Smoky Mountains National Park, TN**

Canon 17-35mm F2.8, at F16, +1, 0, -1 compensations

## LOW LIGHT SITUATIONS

One of the most magical times to make pictures is at dusk and dawn. This time affords endless opportunities to explore your creativity. Many of my favorite images were made well before sunrise and well after sunset. Other than a tripod and electronic release switch, no special gear is required for low light photographs. When the light gets really low you may encounter a few technical problems worth discussing.

The first problem you're likely to encounter is thinking your camera won't meter in very low light. The silhouetted sea stacks from Oregon, below and on page 35, were made 30 minutes after the sun slipped below the horizon. For this scene, I needed F22 for maximum depth of field. Even with a shutter speed set at 30 seconds it was too dark for my camera to get a light reading at F22. Remember that you don't have to meter at the aperture you plan to use. In low light situations start opening the lens aperture until your meter can register a light reading. Once you get a reading, just count the stops back to the aperture you plan to use. For every full f-stop change the shutter speed must double. My initial reading was at F11 at 30 seconds. This is a 2-stop change from F22 so I doubled 30 seconds once to 60 seconds, and then doubled 60 seconds to 120 seconds. Exposures of this length result in underexposure due to reciprocity failure. See the image below.

With very long exposures, slides are often underexposed due to reciprocity failure. This refers to a breakdown in the relationship between f-stop and certain long shutter

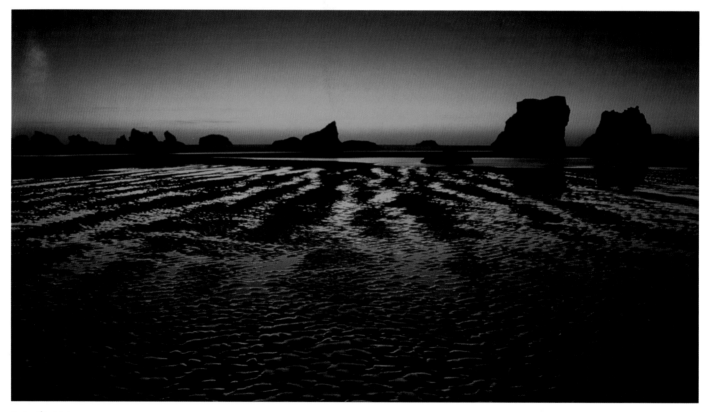

two-minute exposure

**The initial exposure** for this image was two minutes. At this lengthy exposure, reciprocity, is clearly effecting the exposure. I deliberately failed to compensate, resulting in underexposure.

**Bandon Beach, Oregon, 30 minutes after sunset**
Canon 17-35mm lens, at F22, 120 seconds, Velvia

speeds. The real culprit here is the film. As film is exposed at increasingly longer shutter speeds, it begins to lose sensitivity to light, resulting in underexposure. In the field, this means knowing when to add extra light. You add light by opening the lens aperture or increasing the exposure time. Opening the lens is preferred in most cases. Adding additional time simply compounds the problems with an already long exposure.

Reciprocity failure varies with each brand and speed of film used. Kodak and Fuji both have reciprocity information available for all their films. My results in the field seldom agree with their literature. I don't like carrying charts in the field, so I use a very easy to remember method. First off, I don't compensate for most exposures up to about 8 seconds. Exposures ranging from 8 seconds to 14 seconds need about $1/3$ stop extra light. At 15 to 30 seconds add about $1/2$ stop extra light. For any exposure over 30 seconds I simply double the exposure.

So back to our original calculated exposure of 120 seconds. Since this exposure is beyond 30 seconds it must be doubled again to 240 sec. or four minutes. This is exactly the time used in the image below for correct exposure. This is not an exact science. A few seconds one way or the other during a long exposure has little effect on overall exposure. When the exposures get very long, add some additional light to compensate.

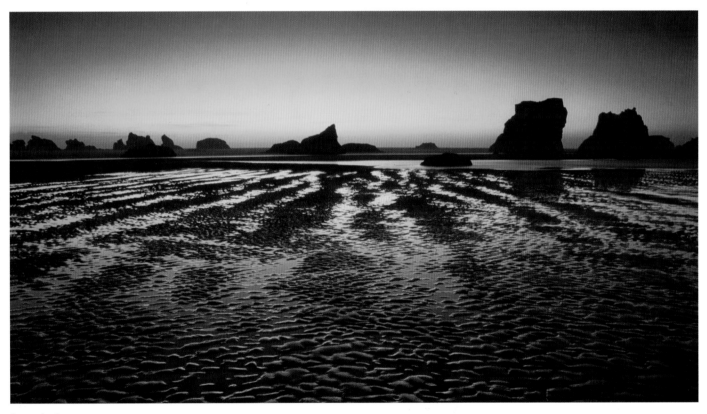

**Four-minute exposure**

**In this image** I doubled the exposure time to four minutes, which compensates for reciprocity failure at very long shutter speeds. Now exposure is correct.

**Bandon Beach, OR, 30 minutes after sunset**
Canon 17-35mm lens, at F22, 240 seconds, Velvia

## SPOT METERING FOR PRECISE CONTROL

Every camera manufacturer proudly proclaims their evaluative metering system as the latest and greatest. Simply turn it on and you're guaranteed perfect exposure regardless of lighting conditions. If only that were true! When the entire image is in sunlight, I've found Canon's evaluative system to be quite good for some situations. On cloudy days it's much less dependable and pros I've spoken with relate similar results with other camera brands.

By definition, spot metering restricts the metering pattern to a small, well-defined area in the center of the viewfinder. This is my favorite metering mode. In the field, I prefer to spot meter right on the main subject or from a single tone in the scene for very accurate metering. You can't depend on evaluative metering to deliver consistently correct exposures when the scene is a mixed bag of light and dark tones. The meter doesn't know how you want the scene exposed or which element in the scene requires perfect exposure. Sure ,you can override evaluative settings, but deciding how much to compensate isn't always intuitive. The problem is you never really know which tone in your scene has the dominant influence on the meter reading. For consistently perfect exposures, you should take control of the exposure process, and spot metering provides exactly the control needed. In this mode you have the advantage of a well-defined meter that lets you decide what to meter. When using spot mode, you must still compensate for your subject's tonality. You must compensate for light and dark subjects as described in chapter two, under Understanding How Your Meter Works.

Let's look at the snowy egret on this page. A mix of light and dark

tones fools the evaluative metering. The egret is a very light tone, the tree an average tone, and the background a very dark tone. Here, I simply shot in evaluative mode with no exposure compensation dialed in. The meter reading is overly influenced by the large amount of dark tones in the background, resulting in overexposure.

In the second illustration on page 37, I spot metered the egret. The subject is a very light tone so I added light by

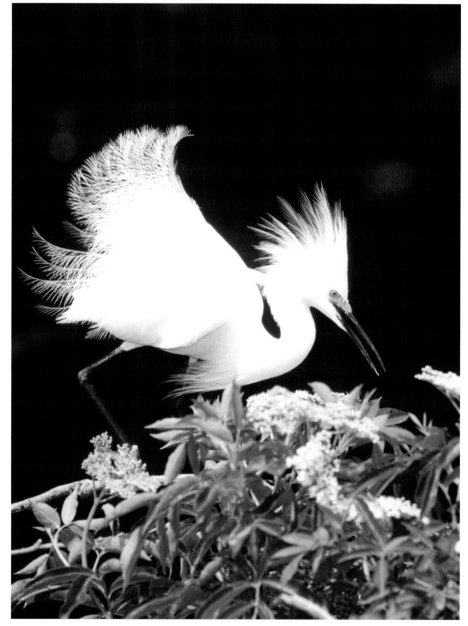

**Snowy Egret in breeding plumage, Everglades National Park, FL**

Canon 400mm F2.8 lens at F4, 1/500 sec. (Evaluative Mode)

slowing the shutter speed by 1½ stops. Spot metering ignored the conflicting tones and with a bit of compensation the egret is perfectly exposed.

When composing your image, the spot meter isn't always where you want to meter. Get in the habit of metering the main subject first. Set your exposure, then recompose and shoot. I find it easier to combine spot metering with a manual mode of setting exposure. In doing so, the meter is set as desired and won't change as the scene is recomposed. With a little practice, you'll get dead on exposures and wonder why you never used this mode before.

**In this illustration** spot metering is clearly more effective. Notice the difference in shutter speeds and exposures. Spot mode allowed me to meter just the egret. I quickly added 1½ stops of light to the initial spot reading to ensure a light tone. Now the exposure is perfect.

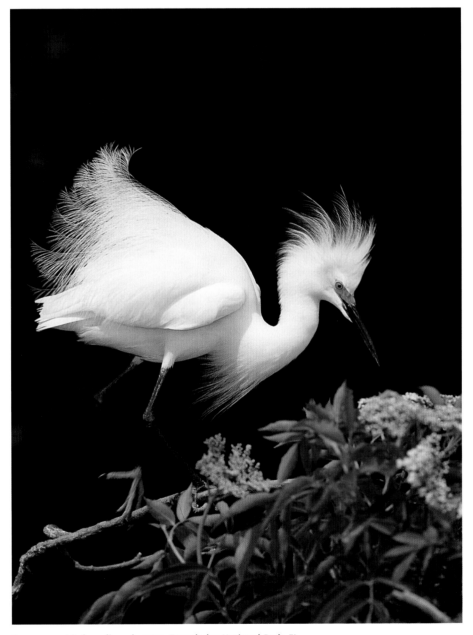

**Snowy egret in breeding plumage, Everglades National Park, FL**

Canon 400mm F2.8 lens at F4, 1/1000 sec. (spot metered)

# USING NATURAL LIGHT

## MORNING

After years of stumbling out of bed in the wee hours of the morning, I still find morning light irresistible. What is it about morning that draws photographers like moths to a light? Once while showing slides of the Grand Canyon to a camera club, a rather indignant lady announced she had photographed from the same location many times, and her pictures didn't look anything like mine. Later I discovered her images were made at high noon. She could not believe that first light made such an incredible difference. It's tough getting out of a comfortable bed early in the morning, but the early bird gets the great photos.

Why is morning light so desirable? When the light is glorious you don't need exotic locations for beautiful images. Morning light transfixes ordinary subjects right in your own neighborhood into extraordinary possibilities. When the light is right, any place can be magical!

The first benefit of rising early is that light has direction. That is, the light is not from high overhead. Early in the day, shadows are long and shapes stand out in bold relief. Unlike midday, you can select a camera position so the subject is frontlit, sidelit, or backlit. Just like a painter, morning light bathes subjects in beautiful warm tones, adding drama to any scene. The one constant governing all natural light is that it's always changing. This is especially true at the beginning and end of the day. Morning light is fleeting, and in a sense a race against time. The quality, color, direction, and intensity are constantly changing.

You never know for sure what each new morning will bring. Whether the light is glowing warm, overcast, or raking hard-edged light, the creative possibilities are limited only by your personal vision and imagination. Each morning has a different look and feel, all of which are worth exploring. Get

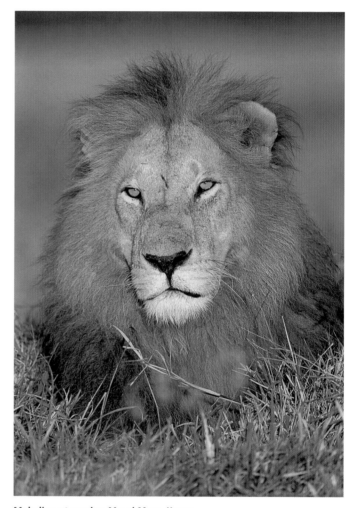

Male lion at sunrise, Masai Mara, Kenya

**This early morning photo** is successful for two reasons. First the lion is bathed in warm golden light that is simply gorgeous. The lion really comes to life because the eyes are beautifully illuminated by low-angled sunlight raking across the savannah. An hour later the morning light is gone and the lion's eyes are in shadow with the sun higher in the sky.

Canon 500mm F4 IS lens, at F4, 1/250 sec., with 1.4x teleconverter, Velvia pushed one stop

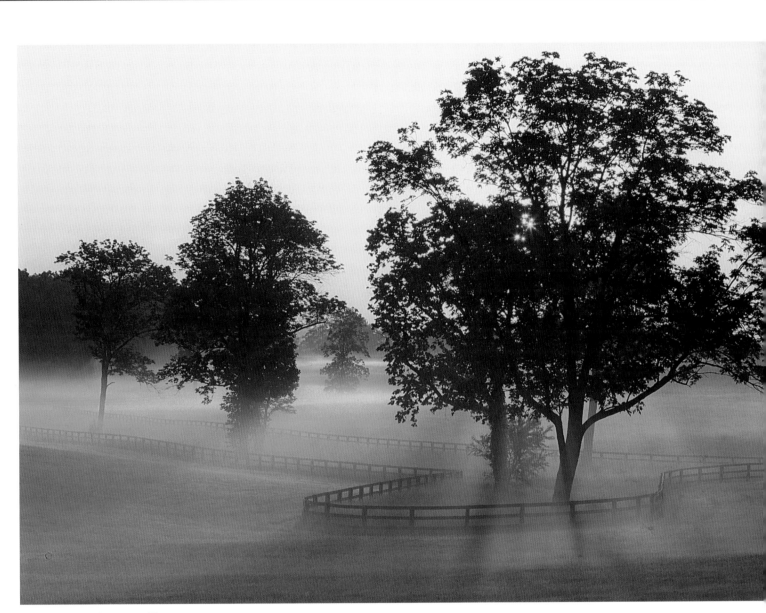

**Sunrise on horse farm, Versailles, KY**

**I passed this horse farm** many times during the day without giving it a second thought. Then early one morning all the elements came together. The sun was just about to rise and a light fog was floating above the pasture; the scene was magical. A little mist and directional warm morning light transformed an ordinary scene into extraordinary opportunity.

Canon 70-200mm F2.8 lens, at F16, 1/15 sec., Velvia

in the habit of returning to familiar areas again and again, and learn to see them in a new light with each visit.

Weather I'm photographing landscapes, macro, or wildlife, early morning is one of the most rewarding times to be in the field. The only way to explore this magic time is to be out early, before it fades into the harsh light of mid-morning. Even if I don't expose a single frame of film, I still enjoy witnessing the beginning of a new day.

## MIDDAY

It's almost blasphemy for a pro photographer to suggest making photos at high noon. Pros even refer to blue-sky sunny days as the sunny kiss of death. I'm not saying mid-

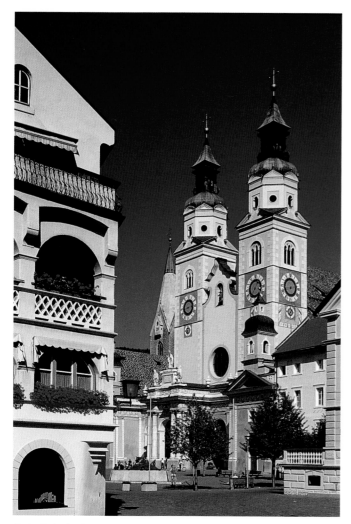

**Cathedral of Brixen, Brixen, Italy**

day light is my favorite, but I am suggesting good images can be made when the sun is high and bright. Midday lighting does restrict the way you operate, but it doesn't mean you should put your camera away. All you really need is a change in your mental approach, and a change in strategy.

Beginners often describe their midday photos as washed out and overexposed. First off, don't try to impose your will on the scene. It is up to you to find scenes that can be recorded when the sun is high and bright. Choose subject matter very carefully and work within the limits of what film can record. Sunny scenes are usually too contrasty, which means there are large differences in exposure between the bright and dark areas. Slide film cannot simultaneously record light and dark areas in direct sunlight. Good color and perfect exposure is possible for the sunlit areas. If part of the scene is sunlit, you must base your exposure on that area. Therefore, parts of the scene not in direct sunlight usually record as black with no detail. Shadows always record darker than they appear, so choose wisely when including them. When metering a high-contrast scene, set exposure by metering from the sunlit areas only; dark shadows fool your meter into overexposing.

Another effective approach is finding subjects completely in the shade. In urban environments simply turning a corner may reveal an entire city block in the shade. When following this strategy, be sure the subject and entire background is in the shade. Otherwise you'll have good exposure on the subject and overexposed hot spots in the background. You will need an 81EF-warming filter for subjects shot in open shade. See Filters on page 10. A polarizing filter is handy for reducing reflections and darkening blue skies. With a little patience you'll learn to enjoy a wealth of small subjects hiding in the shade. Hone your skills at being selective, and your creative vision will improve and sunny days won't be so frustrating.

**For this image** I walked around the entire cathedral before selecting a view with the least amount of distracting shadows. As expected the balconies under the arches are jet black with no detail. The blue sky was darkened with a polarizing filter.

Canon 24mm tilt/shift lens, at F16, 1/60 sec., E100VS with polarizing filter

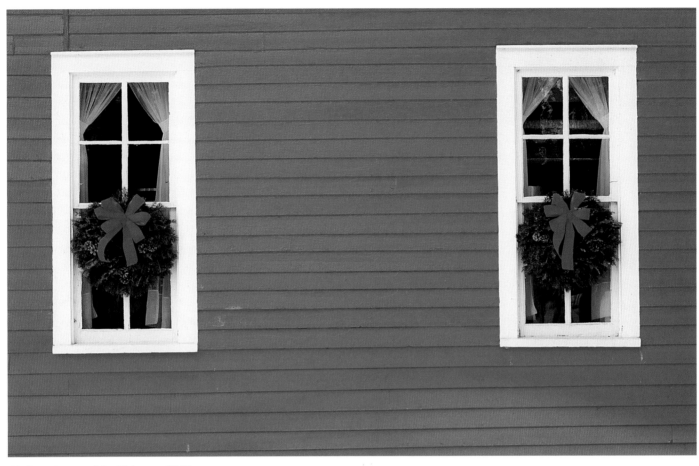

**Windows decorated for Christmas, Michigan**

**These decorated windows** were photographed on a clear, sunny day. A small overhanging roof cast just enough shadow to completely shade the wall and two windows. Framing only the shaded areas resulted in a pleasing image without harsh shadows. An 81EF filter color corrected the bluish cast of the open shade.

Canon 70-200mm F2.8, at F16, 1/4 sec.,with 81EF warming filter, Velvia

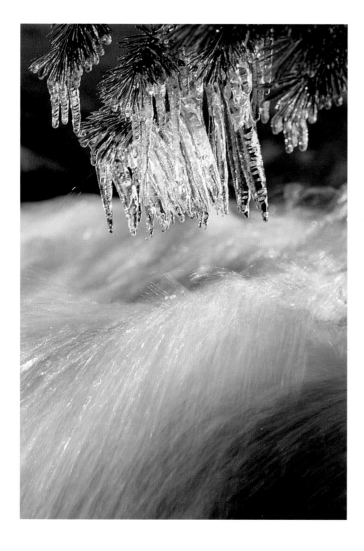

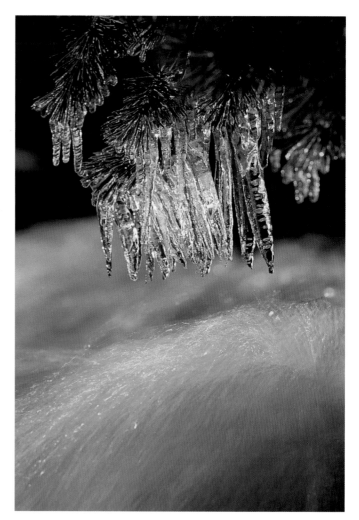

**These two icicle photos** illustrate how time of day impacts the color and mood of an image. Both images were photographed on the same clear day, but the warm version was made about one hour later in the afternoon than the previous version. Neither is right or wrong. Which do you prefer?

**Icicles over small stream, California**

Canon 100-400mm IS lens, F16, 1/8 second for first image and 1/4 sec. for second image. Velvia for both

## LATE AFTERNOON

In many ways, the quality and attributes of afternoon light are much the same as morning light. That said, I find afternoon light a bit softer than morning light. Wind during the day lifts dust particles into the atmosphere, softening afternoon light just a bit. This seems to be especially true in the American West and in Kenya. Overnight the wind is usually calm and morning light can be a bit crisper.

As the sun slowly drifts toward the western horizon, the quality and color of light is transformed. Early and late in the day, sunlight strikes the earth at a steep angle, therefore, sunlight travels through more dust and moisture in the earth's atmosphere. As a result the short blue wavelengths are scattered leaving warm reddish or yellow light. The warm effect is visible to our eyes, but color slide films further exaggerate warm tones.

Color, quality, intensity, and direction are the key ingredients to all light. These attributes are always important, but seldom do they combine in more visually interesting combinations than when the sun is low in the sky. Photography is the art of painting with light; thus the success of any image is largely determined by how we utilize these characteristics. Regardless of time of day, atmospheric conditions, such as clouds, moisture, dust, and fog, constantly influence the quality, color, and intensity of sunlight. As photographers, we should always be alert to these ever-changing qualities. Our job is to decide when, and from where, it best to photograph each and every subject.

Compare the two examples of icicles suspended above a rushing stream on page 42. The difference in color is clearly visible. Both images were made fairly late in the afternoon. The first photo was made about an hour before sunset. The direction and quality of the light is good and the result is a pleasing image. The second version was made about an hour later with the sun low in the sky when natural light shifts to warm tones. Even though I prefer the warm version, I can't really say it's more correct. It's simply different. All that matters is getting what you want. In just one hour, two very different photos were made of the same subject. The point is to realize that light, early and late in the day, is always changing and to utilize it to the fullest.

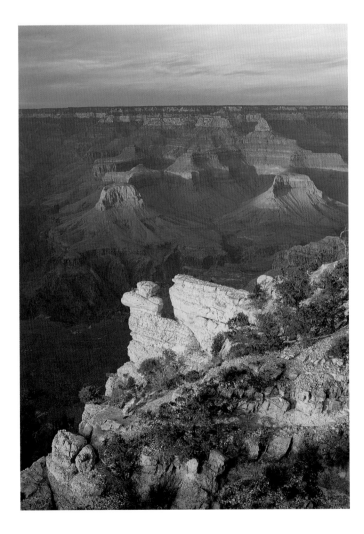

**This late afternoon light** is what I refer to as diffused sunset light. Here warm golden light gently paints the sculptured canyon, yet isn't harsh and contrasty. A thin layer of clouds on the horizon provided just enough diffusion at just the right time for a successful image. Once again timing is very critical.

**Sunset, Grand Canyon, Arizona**

Canon 70-200mm F2.8 lens, at F16, 1/4 sec. Velvia with polarizing filter

## OVERCAST

I often meet photographers on vacations who are quite disappointed when encountering gloomy, overcast weather. This mind-set is wrong! Experienced photographers learn to work around limitations and eagerly embrace overcast light. Granted, some subjects and situations don't work well when it's cloudy, but for others overcast light is best. A gray sky with no detail is indeed boring and should be avoided

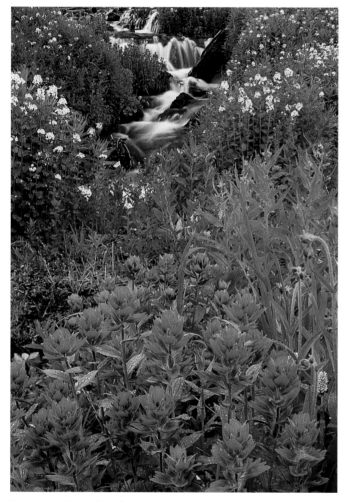

**Magenta paintbrush and mountain stream, Yankee Boy Basin, CO**

**Once again** the beauty and quality of soft low contrast light cannot be overstated. For close-up details on virtually any subject matter, overcast lighting is fantastic. Naturally, a rather long exposure dictates the use of a tripod.

Canon 45mm tilt/shift lens, F16, at 2 seconds, Velvia and 81A warming filter

in most landscape photos. Steer away from scenes requiring a lot of sky and concentrate on finding macro and midrange subjects.

We can see details in bright sunlit areas and shadow at the same time, but film cannot record what we see. Understanding the limitations of high-contrast lighting and the narrow latitude of slide film is critical. Portrait photographers arrange studio lights to illuminate subjects with soft, flattering wrap-around light. Cloudy days allow outdoor enthusiasts to explore subjects in diffused, flattering light valued by studio artists. Like a giant overhead diffuser, clouds reduce contrast and eliminate harsh shadows. When the harsh shadows are gone, you can walk into the forest and make images that are impossible on a sunny day. When the light is soft and diffused, virtually any subject not requiring sky as part of the composition will work. Flowers, plants, waterfalls, close-ups, wildlife, and detail shots are perfect subjects when it's overcast.

Unlike the fleeting, sweet light at the beginning and end of the day, overcast light often hangs around long enough to make images all day. Action shots may require a fairly fast film due to reduced light intensity, but as long as the wind is relatively calm, slow- and medium-speed films are still best for tight grain and rich colors. The wind can be very annoying, but there are usually brief calm periods where you can get a shot. Of course a tripod is always essential, but even more so with the inherent slow shutter speeds under clouds. Since color slide film is balanced for sunny daylight, I use a warming filter when it's cloudy. When it's cloudy every leaf, blade of grass, and wet rock reflects some glare from the overcast sky. These reflections weaken colors tremendously. A polarizing filter greatly reduces any unwanted reflections helping to maintain saturated colors. See Filters on page 10.

When you're faced with never ending sunny conditions and you need diffused soft light, try working 30 minutes before the sun comes up and 30 minutes after the sun dips below the horizon. This situation provides soft indirect light similar to overcast with one very important exception. Photos made while the sun is below the horizon can be very blue. Strong 81C or 81EF warming filters are required to correct the blue cast on film. When it's cloudy and the wind is calm, don't miss out on nature's studio lighting; go out and explore a world of endless possibilities.

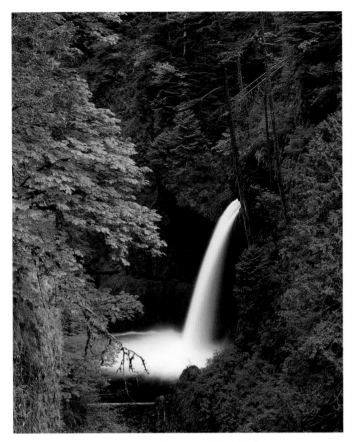

Located in a deep heavily forested gorge, this lush scene is impossible to record properly with sunny conditions. On a cloudy day, the average green foliage and white waterfall are both perfectly exposed with low-contrast, overcast lighting. Even the darkest recesses have good detail. A complete absence of wind permitted a long 4-second exposure.

Canon 100-400mm IS lens at F16,4 sec., Velvia with polarizer and 81A warming filter

**Metlako Falls cascading into Eagle Creek, Columbia River Gorge National Scenic Area, OR**

## Photographing urban street scenes

can be very tricky on sunny days, but in this situation overcast lighting saves the day. Using nature's own studio lighting, the white umbrellas and all other tones have equally perfect exposure and no harsh shadows. Notice the cropping at the top of the image. Using a short telephoto lens, a dull gray sky was completely eliminated from the composition.

Canon 70-200mm F2.8 lens, at F5.6, 1/15 sec., E-100VS with 81A warming filter

**Outdoor cafe, Fussen, Germany**

**Arch framing Mt. Whitney and Lone Pine Peak, eastern Sierra range, CA**

**This sunrise image** was made with strong sidelight from the left. I wanted the rough texture of this arch to reproduce on film. Directional light sculpted every surface imperfection into bold relief, emphasizing the pitted texture of this ancient arch. The shadow below the arch also adds a sense of height.

Canon 17-35mm lens, at F16, 1/2 sec., Velvia with polarizer

**Directional light** from the side and behind this mule deer provides perfect rimlighting for antlers in velvet. I deliberately chose a position aligning the deer's rimlit antlers against the dark, shadowed area of distant trees. To meter this scene I simply spot metered the sunlit grass and opened up one stop for perfect exposure.

Canon 500mm F4 IS lens, at F4, 1/125 sec., E100VS

## DIRECTIONAL LIGHT

In previous chapters we examined the pitfalls of harsh shadows and gained an appreciation for low-contrast lighting. High contrast situations are often disastrous on slide film, but we also need to understand when shadows are working to our advantage. As a compositional element, shadows play an extremely important role. Images recorded on film are two-dimensional representations of a three-dimensional world. Well-placed shadows are the basis for adding depth, texture, and dimension. In the purest sense photography is a study of light and shadow. Designing a great image depends on how well you recognize and organize the relationship between light and shadow. Each situation is so unique; there are no set rules or guidelines.

Light always has direction, but early morning and late afternoon are by far the best times for utilizing directional light. It's nearly impossible to include shadows effectively when the sun is high overhead. Here we go again, another good reason to be out early and late in the day. With the sun low in the sky, we have many options in selecting a viewpoint relative to the sun and subject. Let's try a little exercise. With the sun low in the sky, begin with the sun at your back, casting light over your shoulder onto the subject. This is front lighting because the subject is lit from the front. Front light is fine in many respects, but it lacks the direction needed to carve any depth and dimension around details. Now let's move 90 degrees to the direction of the sun where the subject is lit from the side. When a subject is

sidelit, shadows are long, well defined, and to the side. The slightest irregular feature creates a shadow that adds definition and dimension. This is good news. Our minds perceive shadows as depth in a two-dimensional image.

Let's move another 90 degrees to a viewpoint where the sun is behind the subject. The camera is now pointed into the sun. By definition a subject is backlit when illumi-

Tallgrass prairie at sunset, Iroquois Conservation Area, IL

**Here backlighting** dramatically emphasizes the delicate translucent edges of the Rattlesnake Masters and Prairie Blazing Stars. Light raking across the meadow toward the camera adds a feeling of depth to the image. Camera position was selected to place the sun behind the tree to help eliminate lens flare. As usual I used a lens hood on my lens.

Canon 17-35mm lens, at F16, 1/30 sec., Velvia

Rimlit mule deer, Glacier National Park, MT

nated from behind. Backlit shadows extend toward the camera adding shape and texture to irregular surfaces. Once again shadows fool us into perceiving depth. Subjects with translucent areas are delightfully accented with backlighting. Rimlighting occurs when strong light from behind graphically outlines translucent areas around the edge of the subject. Familiar examples include velvet on deer antlers, cactus spines, and plant foliage.

Many beginners thrill at photographing pretty skies at sunrise and sunset. Why concentrate so much on capturing color in the sky? Chasing sunrises and sunsets is okay, but I find a lot more opportunities when looking for subjects lit with beautiful directional light at sunrise and sunset. A lens hood is especially important when dealing with strong side or backlighting. This device helps maintain top optical quality by eliminating potential lens flare. The next time you're flipping through a top-quality photo magazine, notice how many of the memorable images are made with either backlight or sidelight. You might be surprised. Once you start creatively using directional light, your photography will never be the same.

## SILHOUETTES

Silhouettes are a fun, easy way to expand your photographic creativity. The first step is to make sure your subject is backlit. All backlit scenes are not silhouettes. When creating a silhouette, simply choose an opaque subject in front of a bright background and expose for the background. The end result is a black outline revealing a subject's shape in silhouette. Sunrise and sunset skies are perfect colorful backgrounds; water and snow are also very good.

Silhouettes are a simple way to emphasize a subject's shape. Look for subjects that have a bold yet simple shape. For best effect, subjects should be identifiable. Composition should be clean and uncluttered for maximum impact. Select subjects with dynamic shape for the most dramatic images. Carefully avoid settings where objects merge into large black clumps. Also keep a watchful eye on the horizon. A common mistake is including far too much black foreground. Crop foregrounds to a minimum. A large black area beneath the subject is just wasted space. Keep in mind that everything below the horizon records as black with no detail. Even though good silhouettes are usually simple compositions, a

bit of artistic creativity and technical skill is required.

The best way to expose for silhouettes is to spot meter the bright background to the side of the subject and set exposure as desired. If your camera allows, shift into manual mode, set your exposure, and then recompose as desired. This way your meter won't automatically readjust exposure for dark subjects, resulting in overexpose. There is no one correct exposure for silhouettes, a variety of exposures will give excellent results. If you are unsure, bracket from $1/2$ stop underexposed to $1 1/2$ stops overexposed for best results.

If the sun is high in the sky, move around until your subject blocks the sun from view. When close to your subject, a wide-angle lens is very effective in reducing the sun's size so it can be hidden behind the subject. A great addition to any slide show, silhouettes seem to have an almost universal appeal. In some cases a silhouette is the only way to get the image.

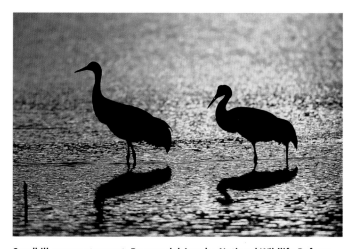

**Sandhill cranes at sunset, Bosque del Apache National Wildlife Refuge, New Mexico**

**All that's needed** for great silhouettes is a subject with dynamic shape and a bright background. In this case, a pair of sandhill cranes provided the dynamic shape and the lake shimmering at sunset provided a bright background. Spot metering the water, I opened up $1/2$ stop to ensure the water would be bright enough to contrast with the birds.

Canon 500mm IS lens + 1.4x teleconverter, at F5.6, 1/30 sec. , E-100VS

**Biker at sunset, Louisville, KY**

**For this assignment** I situated a model on a slight rise in an open field. Shooting from ground level, my angle of view eliminated distracting trees in the background. Spot metering the bright sky around the model, I opened up $1/2$ stop leaving a perfect silhouette of the biker's shape.

Canon 100-400mm IS lens, at F8, 1/60 sec., Velvia

**Tree silhouetted at sunrise, Cumberland Gap National Historic Park, KY**

**When silhouetting trees** against a beautiful sky, make sure the entire tree is visible. Find a viewpoint where the tree doesn't merge with the ground or other surrounding elements. Scout locations ahead of time so you know where to be when conditions are right.

Canon 100-400mm IS lens, at F16, 1/4 sec., Velvia

# COMPOSITION BASICS

## WHAT TO INCLUDE

Don't think for a minute that I'm telling you what to photograph. That choice is totally at your discretion. Photograph whatever you find interesting. Regardless of subject matter, the first step toward good composition is learning what to include. A composition is successful when you've made a pleasing selection of elements within the picture area. This means selecting the best possible subject you can find and carefully incorporating any supporting elements. Well-composed images don't just happen; they are the result of careful planning.

Including too many subjects or elements is the biggest mistake made by beginners. Failing to eliminate visual clutter weakens the subject's visual interest. Look for ways to give the primary subject the most visual attention. Keep it simple: Simplify, simplify, simplify. When composing a picture, ruthlessly eliminate everything not strengthening the subject's visual impact. I doggedly approach every scene looking for elements to eliminate from every composition. It's rare to find subjects visually isolated from their surroundings, so secondary elements must be carefully considered to complement the center of interest.

Usually, whatever first catches your eye should be the primary subject. Zero in on the initial point of interest and consciously work to find a point of view that defines your interest. As composition is fine-tuned, the original concept of the best image may change. This is perfectly normal and to be expected. It is an essential step in the process of defining your subject.

**This first image** is ambiguous. The subject isn't clearly defined. The road, the cliff, the distant ridge compete with the rooftops for visual attention. Shadows in the lower right side of the image are also harsh and distracting.

Canon 100-400mm IS lens, F16, 1/15 sec. + polarizing filter, E100VS

**Rooftops, Roussillon de Provence, France**

**In this second image** I changed my viewpoint slightly and used a vertical composition to eliminate the harsh shadows. The composition is better, but the rooftops are still competing with the surroundings.

Canon 100-400mm IS lens, F16, 1/8 sec. + polarizing filter, E-100VS

**Rooftops, Roussillon de Provence, France**

**Rooftops, Roussillon de Provence, France**

**In this final version** I zoomed to a longer focal length and eliminated the remaining clutter. Now the image has visual impact. There are no distracting elements to compete for attention with the repeating pattern of tile rooftops. Of course it isn't necessary to shoot three versions; with practice you'll learn to mentally eliminate the distractions beforehand.

Canon 100-400mm IS lens, F16, 1/8 sec. + polarizing filter, E100VS

**First composition**

**Second composition**

**This series** of images clearly illustrates how changing your viewpoint results in three totally different photos. I carefully scouted the courtyard and passageways until I found a pleasing composition. Once satisfied with your first perspective, don't snap one view and then move on. Keep looking and exploring other options Move left or right, and try a higher or lower vantage point. It's surprising how many times a second or third composition turns out to be the best.

**Hydrangea bush, Maison De Sante St. Paul, St. Remy De Provence, France**

Canon 17-35mm F2.8 lens, F16, 3 seconds + 81A warming filter, Velvia

Once a subject is framed, look around the viewfinder for distracting details creeping in around the edges. Often our attention gets focused on the subject or mechanics of the camera and we overlook obvious distractions around the edges of the picture. Striving for visual simplicity also applies to backgrounds. Unless you are photographing flat artwork, nearly every image has a background. Keep them clean and simple so attention isn't diverted from the dominant subject.

The world is full of visual chaos; we apply some order by making conscious decisions on what parts to include. A painter starts with a blank canvas and then adds only the desired elements. The photographer must eliminate visual clutter. For visual impact, choose subjects very carefully and then eliminate everything else. Great composition is a delicate balance between what is included and what is left out.

## POINT OF VIEW

Point of view is the next building block for good composition. When deciding what to include, move around the subject and explore various angles and viewpoints. Changing your viewpoint is one the most effective ways to control composition. You are looking for that perfect spot or perspective where the image is most effectively framed. Once you find the perspective you like, simply choose the appropriate lens to capture the desired portion of the scene. Point of view is important because it effects every element in the image. Change your point of view and the spatial relationship of every object in the composition changes relative to the others. Objects closer to the lens appear larger than do those farther away. From a great distance two tall buildings appear to nearly touch one another. As you move closer, the buildings appear to move further apart. Standing beneath them at street level you see enough space for cars and trucks to easily pass between the buildings. What caused the change? The buildings didn't move. You moved closer, and in doing so changed your point of view.

The ideal point of view is that spot where all the objects in a scene line up into an organized and pleasing composition. Don't just walk up to a subject and snap the shutter. Move completely around a subject before taking a picture. Placement of the camera has an enormous effect on the background. When moving around your subject look-

**Third composition**

ing for the best perspective, do so with your camera in hand, and not on a tripod. With a camera mounted on a tripod, the whole rig is cumbersome and tiring to move around, and in frustration you'll wind up settling for less than the best composition.

Always taking photos from your eye level is a common mistake. The creative effect of the camera's height relative to the subject is often overlooked. A common example is photographs of small children taken from adult eye level. Aiming down, the child is diminished and the perspective is foreshortened. Kneeling down, level with the child, is such a simple adjustment, yet the perspective is dramatically improved. Conversely, aiming up at a subject extends perspective, making objects appear larger and taller.

Beginners often choose a viewpoint too far away from the subject. Failing to get close enough, you end up with unwanted objects or wasted space diminishing the subject's importance. Move in close and fill the frame for dramatic impact. Close-ups portray a sense of intimacy with the subject, while distant shots lend a sense of distance and depth. Getting closer inherently decreases depth of field, softening background clutter. Keep these basic suggestions in mind until they become second nature, and soon you'll be creating masterful photographs instead of taking snapshots.

## ARRANGING ELEMENTS

Once you've selected a subject, reduced secondary elements to the bare bones, and found the most advantageous point of view, it's finally time to frame the picture. Photographers do indeed face a world of visual chaos, but effectively arranging subjects and supporting elements within the viewfinder need not be daunting. Arranging elements where they flow through the picture is most effective. Use leading lines to give the eye something to follow through your composition. In Western society it is generally believed the viewer's eye enters an image from the bottom left and scans the image from left to right. Images with leading lines flowing from the lower left to the upper right are naturally easy for the eye to follow. Use the graphic power of leading lines to direct the viewer to the subject, but not out of the photo. A river meandering across a meadow or a road winding through the forest are classic examples.

When designing a photograph, it helps to think of elements primarily in terms of their graphic shape and form. Visualize objects as basic building blocks, such as squares, triangles, circles, lines, and curves. Then arrange them graphically in a pleasing manner. Let's say your subject is a river meandering through a meadow. Where should a river be placed in a scene? I don't know! There is no rhyme or reason for arranging a river in any particular way. Now, visualize the same scene like a graphic artist considering only the shape of the river. As a design element of shape, the river's curves can be arranged to flow through a scene in harmony with other shapes. The river's graphic shape is a perfect leading line.

Generally, it is not considered good composition to have a subject too centered or balanced. This puts too much weight or emphasis dead in the center of the image. Placing the main subject off center and balancing the weight with other objects is more effective. A good general guideline is known as the "Rule of Thirds." As you can see from the illustration below, an image is divided into thirds both horizontally and vertically. The four intersecting points on the grid are usually where the main point of interest should be placed. You have four off-center locations for horizontal compositions and four off-center locations for vertical orientation. The rule of thirds is only a starting point, don't let it become an inflexible formula for composition.

Horizons are probably the single most encountered line in outdoor photography. A horizon line through the center of the frame is usually considered static and boring because

**This grid** divides an image into thirds, both horizontally and vertically. The four intersecting points on the grid are the power points where the main point of interest is usually placed. There are four off-center locations for horizontal compositions and four off-center locations for vertical orientation. This layout is useful as a starting point, but don't consider it an inflexible formula.

**Rule of thirds**

the frame is too evenly weighted. Place the horizon line in the upper third of the frame and emphasis is placed on the foreground. Place the horizon low and the emphasis shifts to the sky. While learning, it is a good idea to stop and verbalize your reasons for placing graphic elements as you do. Always study your results and learn from your failures so you won't keep making the same mistakes. In regard to composition guidelines, keep the following in mind from Ansel Adams:

"There are no rules for good photographs, there are only good photographs."

**These two compositions** illustrate how placing the horizon line affects composition. Neither is right or wrong, just different. Using the rule of thirds, one image has the horizon line in the upper third of the frame. Due to its larger size and weight in the frame, emphasis is placed on the foreground. When the horizon line is lowered to the bottom third of the frame, the emphasis and weight shift to the sky.

**Field of mustard flowers, Paloose farm country, WA**

Canon 17-35mm F2.8 lens, F16, 1/2 sec. + polarizing filter, Velvia

**Good composition applies** to every shot you take, including small macro subjects.

Pennsylvania leather-wings mating, Louisville, KY

Canon 180mm macro Lens, F16, 1/250, full flash, E100VS.

**In graphic terms** the road in this shot is merely a curving line directing the viewer's eye through the image. The lines of the road converge in the distance creating an illusion of depth in a two-dimensional picture. The trees are proportionally large and heavy in the upper left of the frame, but the road helps balance the lower right third of the frame.

Hyatt Lane, Cades Cove, Great Smoky Mountains N.P. TN.

Canon 28-135mm IS lens, F16, 1/4 sec. polarizing filter, Velvia.

## DEPTH OF FIELD

Depth of field is a critical factor in designing any well-crafted image. It's easy to get caught up in the moment and give little creative thought to aperture selection and its impact on the image. Worse yet, you let the camera make all the decisions. You should take control of the camera; after all, these are your photographs. Make a habit of consciously applying depth of field to achieve the creative result you want.

Depth of field is defined as the area in front of and behind the actual point of focus that appears to be sharp. Think of it as depth of focus. This zone of apparent sharpness is determined by two factors: magnification and aperture. Notice I didn't mention focal length.

Depth of field is not a function of the lens used. Magnification and aperture determine depth of field. You can prove this point by shooting the same subject with quite different focal length lenses. Keep subject size the same with both lenses, use the same aperture, and both images will have exactly the same depth of field. The background and distance from the subject to camera will be different, but the area in focus will be the same. Don't wide angles have more depth of field? No, they do not! If you stand in one spot and shoot a scene with a wide-angle lens and a telephoto lens, the wide angle will indeed have more depth. This is because the wide angle is magnifying the scene much less than the telephoto lens. In doing this you are comparing vastly different images with far different magnifications, which is not accurate for comparing depth of field.

Stopping a lens aperture down to F16 or F22 adds the greatest depth to the zone of sharpness. Conversely, opening up to apertures around F2.8 and F4 reduces the zone of apparent sharpness. Regardless of the aperture selected, moving closer to the subject increases magnification and reduces depth of field. Moving further away from the subject decreases magnification, therefore increasing depth of field for any given aperture. Roughly two-thirds of the depth of field extends behind the focus point, and one third will extend in front of the focus point.

Landscapes are a prime example where apertures of F16 and F22 are commonly used. For landscapes I usually want everything from the nearest point to the most distant point in sharp focus. This is accomplished by stopping the lens way down to around F16 or F22. When photographing wildlife with a long telephoto lens, I need wider apertures to stop subject movement and camera shake. I nearly always use aperture priority so I have exclusive control of aperture. Aperture selection is a critical creative judgement, therefore I always select aperture first and almost never let the camera choose for me. Selecting an aperture is often a compromise based upon what you decide should be in focus, and what conditions in the field will allow. Landscapes, macro, action, and long telephotos all require something different. Depth of field at F16 on a macro shot may only be a millimeter, while a landscape at F16 may be in focus from a few feet to infinity.

Controlling depth of field allows many creative possibilities. When the subject and all other elements are in sharp focus they are creatively and visually linked. Traditional landscapes are a perfect example where all elements are linked with sharpness throughout the image. But many subjects need to be separated from their surroundings. The trick is opening the lens up just enough to ensure adequate subject sharpness, but not enough to reveal distractions in the background. Basically the closer we get to the subject, the easier it is to blur out the background for any given aperture. The more you photograph and study the results the faster you'll master the creative use of depth of field.

Cameras equipped with a depth of field preview make the process much easier. This feature allows you to see the image at your selected aperture before taking a picture. With a little practice, using the depth of field preview isn't difficult. Begin with the lens wide open, then activate the preview button, and slowly stop the lens down in small increments until the desired effect is achieved. With this technique your eye can adjust slowly as the lens stops down and the viewfinder darkens. Make a habit of using the depth of field preview. Then you'll know exactly what's in focus and if you've overlooked any distracting elements.

There is no one best way to use depth of field. Too many variables factor into each situation. The slightest breeze in a field of flowers impacts the choice of aperture and resulting shutter speed. There are times when opening up will improve a composition and times when stopping the lens down is the best strategy. Your personal vision, the subject matter, and each situation can be interpreted many ways. The lesson here is to understand the importance aperture selection plays in your creative expression.

F22

F4

**The image on the left** was made at maximum depth of field (F22) with a 180mm macro lens. This close to the subject (high magnification) depth of field does not fully extend to the purple flowers just inches behind the Coreopsis. Maximum depth of field in this situation is confusing to the eye. The subject is not clearly defined because the partially focused purple flowers are distracting. In the image on the right everything is exactly the same except the lens was set at F4 for minimal depth of field. By opening up, the background becomes a gentle wash of color, separating the subject from the background.

**Coreopsis, Louisville, KY**

**Both images** are made with the same 180mm macro lens used in the previous flower example. In this illustration the lens is much farther away from the subject (low magnification) where the depth of field is much greater at any given aperture. Compare the depth of field at F4 on this row of trees (a few feet) to the depth of field at F4 on the Coreopsis (a few millimeters). This clearly illustrates how depth of field increases as we move farther away from the subject for any given lens. The top image at F4 is visually flawed because greater depth of field is needed to link all the trees together. In the bottom image I stopped down to F22 and all the trees are sharp and visually linked together. At this magnification and aperture the zone of sharpness is well over one hundred feet.

**Row of trees, Louisville, KY**

F4

F22

**F22**

**This last image** illustrates the classic use of a wide-angle lens for landscapes. Here I placed my camera with a 28mm wide-angle lens about two feet from the foreground flowers and stopped down to F22. Using a wide-angle lens relatively close, subject magnification is still small and the wide-angle lens sees a lot of territory, so depth of field appears to be endless.

**Bluebonnets and paintbrush, Texas Hill Country**

# 5

# ELEMENTS OF COMPOSITION

## FORM

The design elements of form, line, color, and shape are the fundamental building blocks of all photographs. They can be used singularly as abstracts or in fascinating and complex combinations. Training yourself to see and organize these visual design elements is a key step in the process of becoming a better photographer. Your goal is to find and arrange them into harmonious compositions. Learn to recognize these elements and ruthlessly seek them out for eye-catching compositions.

Shape and form are not the same thing. An object has shape when viewing its outline in two dimensions—height and width. Shapes are flat and forms are not. An object has form when it has three dimensions: length, width, and depth. Since photographs are flat representations of our three-dimensional world, an object's form helps us perceive depth and dimension in pictures. Light striking your subject at an angle creates the shadows necessary to emphasize form. Having no control over the sun's position, we must find a viewpoint where the light and shadows interact to form a pleasing picture.

Front lighting is a poor choice for enhancing form. Instead use sidelight or backlight to create the shadows revealing an objects form. Hard, strong light is perfect for creating shadows, but the shadows can be overwhelming, and as a design element, they must be considered just like any other compositional element. Directional light can be fairly diffused and still reveal form. Indirect window light is diffused, yet it provides directional light with soft pleasing shadows. Become a student of light and form. Look past what subjects really are; study the way objects and light interact.

## LINES

Look around, we can hardly get away from lines. Lines are a very powerful element of design that exhibit a profound influence on composition. Snapshooting haphazardly with no concern for lines is a prescription for disaster. To grow as a photographer, develop a keen eye for lines and understand their influence on your photos. Lines are commonly used to lead the viewer's view through the picture. We all know the way converging railroad lines imply depth in a two-dimensional photograph. But lines impart much more than just depth. Depending on placement and direction, lines arouse powerful human emotions.

We respond to horizontal lines with feelings off calm, serenity, and peacefulness. A flat lake or pond is a strong horizontal element or line that we associate with serenity and tranquility. From an emotional standpoint, horizontal lines reduce the excitement of a photo. Vertical lines elicit a completely different response. The vertical lines of skyscrapers, trees, and mountains embody feelings of strength, power, and grandeur. Standing beneath a grove of giant sequoias is a humbling experience. Why? The towering heights of the ancient trees easily dominate our presence on the ground. The same principal holds true for your compositions. Incorporate lines leading upward to emphasize a subject's power and dominance. Wide-angle lenses are especially good for exaggerating the sense of height when aimed upward from a low angle.

Diagonal lines express a sense of movement and a way for the viewer to enter the picture. Strong diagonals bestow a sense of dynamic action and excitement. How many times have you seen a new car commercial on television using a dramatically tilted horizon? Normally, this is considered a

Canon 70-200mm F2.8 lens, F16, ¹/₄ seconds polarizing filter, Velvia

**These two images** from the Smoky Mountains demonstrate how directional lighting enhances form. In one image, shadows cast by angled morning light create bold form as they alternate between the sunlit ridges. This greatly emphasizes the ruggedness of the slopes. Compared to the shadowless version made on a bright overcast day, the scene has more depth and three-dimensional quality.

**Deep Creek Valley in autumn, Great Smoky Mountains National Park, NC**

Canon 70-200mm F2.8 lens, F16, ¹/₁₅ seconds polarizing filter, Velvia

mistake, but in this example the tilted horizon creates a diagonal, enhancing the sense of action and excitement. As a result, the commercial gets our pulse racing even when the featured autos are totally lacking in excitement.

One of the most beautiful lines is the S-curve. Commonly found in nature, the S-curve is graceful, well balanced, and a line to look for when composing your pictures. This curve is no stranger to the art world; painters have created this elegant line in paintings for centuries. Whether man-made or natural, use S-curves to add a sense of grace, flow, and balance to your images.

**Maple tree in autumn, WV**

**Slickrock formation, Paria Canyon, AZ**

**The tree's dark trunk** in this image is a strong vertical line directing the viewer's attention upward through the picture. A wide-angle lens from a low viewpoint exaggerates the tree's sense of height and dominance.

Canon 17-35mm F2.8 lens, at F16, 1/4 sec. polarizing filter, Velvia

**In this image** the graphic pattern of repeating lines is the primary subject. Parallel lines sweep up and around from the lower left directing the flow up to a strong diagonal line framing the upper right corner. The diagonal line effectively shifts attention to a secondary element in the distant background.

Canon 17-35mm F2.8 lens, at F16, 1/30 sec. polarizing filter, E100VS

**Cumberland River at sunrise, Cumberland Falls State Park, KY**

**Here a classic S-curve** is used to lead viewers into the photo from the bottom right. The beautiful curves of the river ultimately direct attention to the sunrise. Note the placement of the horizon line. In this instance, placing the horizon line through the middle of the frame is fine. The sky and the land features are given equal weight or balance.

Canon 28-135mm IS lens, at F16, 2 sec. polarizing filter, Velvia

## COLOR

Color film is the overwhelming choice for most photos, yet many aspiring photographers overlook the impact of color in the final picture. Using color goes well beyond simply making an image colorful. Powerful human emotions are aroused by color. For example, an image with a large amount of blue sky elicits one kind of emotional response. Imagine the same scene with a gray sky and the response is quite different. With such an effect on our psyche, color is an extremely powerful element of design. Bright vibrant colors grab the viewer's attention and stimulate a sense of excitement. The eye is immediately drawn to the brightest and lightest colors in a photo. Stay alert to the way colors interact in a photo. Your subject and any secondary elements of color must work together in harmony. Like the other primary elements of design, always consider the size, placement, weight, shape, and intensity of color.

Complementary colors combine to create color har-mony. A red leaf resting on a green moss-covered rock is said to be in harmony and pleasing to the eye. How many times have you seen an adventurer wearing red in a *National Geographic* publication? Now you know why; a vibrant red shirt grabs your attention and is in perfect harmony with the green colors of the great outdoors.

Pastel colors elicit emotions of quiet and calm. They are moody and subordinate to the subject matter. Muted colors tend to work better in color harmonies than do bold strong colors. Red and orange are considered strong or advancing colors, while blues and greens are cool receding colors.

Bright colors are usually associated with the foreground, since color tends to be muted with distance.

The best advice for using color is to keep it simple. Don't overwhelm the viewer with complex compositions. Think about color as a powerful way to define your visual center of interest or to evoke a particular mood.

**Fall color on stream, Great Smoky Mountains National Park, TN**

**Sunset, Great Smoky Mountains National Park, TN**

**Sunrise, Great Smoky Mountains National Park, TN**

**Compare the way** color impacts the mood of these two images. The sunset image with bright, vibrant color is more exciting and dynamic. The bold, red sky dominates the trees. The soft, muted pastels in the sunrise image evoke feelings of peace and tranquility. Here the pastel sky is subordinate to the trees.

**Sunset:**

Canon 100-400mm IS lens, F16, 1/125 sec., Velvia

**Sunrise:**

Canon 100-400mm IS lens, F16, 1/4 sec., Velvia

**This image** is all about seeing and using color. There was only one viewpoint on the stream bank where this stream reflected the fall color. The bright vibrant tones of the gold water help balance the dark shapes of the rocks in the water. The vibrant color and relative brightness of the water effectively leads the eye through the picture.

Canon 100-400,mm IS lens, F16, 2 sec. blue/gold polarizing filter, E100VS

**Here I purposely failed** to isolate the mum pattern by allowing the white flowers to creep in along the edge of the frame. This is an example of what not to do. The white flowers confuse and distract from the main subject. In the second example I moved closer and carefully isolated my pattern from the surroundings. In this situation, the isolated pattern is the best picture.

**Pattern in mums, KY**

Canon 180mm macro lens, F16, 1 sec. E100VS

## PATTERN AND TEXTURE

We are naturally attracted to patterns and textures—they are everywhere. Our minds recognize the order and symmetry of pattern, which makes it an effective element of composition. Pattern is created when lines, shapes, colors, or textures are arranged in repeating intervals. Upon close inspection, patterns are abundant in nature as well as in man-made designs. Once you start recognizing these basic design elements, you can easily create interesting photos of pattern and texture. In some instances pattern alone is the subject. In other situations, patterns best identify objects when used as part of the overall scene.

When emphasizing pattern as the subject, make sure the design is truly outstanding. Patterns are great for emphasizing a recurring theme, but repetition alone can be boring. Overly repetitious themes can become monotonous. Show a break in the pattern by adding another point of visual interest. Try to include another element to break up the pattern without diluting the overall strength of the photo. That said, a common mistake is failing to isolate an otherwise great pattern. Make sure any breaks in the pattern help the composition and don't divert the viewer's attention. When you find a pattern, go in tight and exclude any distractions.

Texture is like icing on the cake. It provides that extra tactile sense of feel to a two-dimensional piece of film. Texture is the play of light upon surface irregularities; it's what prompts us to reach out and feel the picture. Surface irregularities such as bumps, flakes, cracks, dips, and ridges are best emphasized with light at an oblique angle. Texture lets us connect with the subject on a higher emotional level. We are so familiar with texture in our everyday lives, that seeing it in a photo elicits a powerful response.

**Here I used** a cactus in the foreground to show a break in the main pattern. This avoids the monotony of simple repetition by adding a secondary point of interest. Make sure the secondary element looks as though it belongs in the picture.

**Golden barrel cactus, CA**

Canon 180mm macro lens, F16, 1 sec., E100VS

## SHAPE

When organizing elements within a composition, it helps to look beyond objects as specific things. Analyze the object's shape before snapping a shot. Make sure the shape fits harmoniously within your scene. For example, don't try to think about where a tree should be placed in your composition. Instead, let the tree's shape and the way it relates to its surroundings guide placement. Shape refers to an object in two dimensions: width and height. Having only two dimensions, a silhouette is pure shape; there is height and width but no detail or dimension to the outlined shape. Shape itself is the subject in a silhouette.

We know solid objects possess shape, but we must also consider some transitory elements of shape as well. Light and dark areas are not always solid objects, but they do create additional shapes that must be considered and organized. Shapes can be made more dominant by placing them in front of backgrounds with contrasting colors or bright-

**Shi Shi Beach, Olympic National Park, WA**

**This image** has a variety of natural shapes interacting with golden light and mist. Some of the rock shapes appear as heavy solids and others have a lighter, more ethereal feeling from the mist. The shapes are arranged to work well with the direction and quality of light and the reflective pools of water on the beach.

Canon 28-135mm IS lens, F16, 1/30 sec., Velvia.

ness. A shadow isn't a solid object, yet it must be dealt with in the composition. Reflective surfaces mirroring color from the sky add shapes of color that must be considered.

Nearly everything in a scene has some kind of shape. Evaluate every scene by carefully studying its basic configuration of shapes, and make sure they are working together in harmony. Each shape has relative size and weight; try to achieve balanced composition. Keep it simple, limit your point of interest to a single shape or subject.

**Pure and simple,** this image is all about the graphic shape of the trees. Placing them in front of the contrasting color and brightness of the sky emphasizes their shape. The weight and flow of the branches is directed toward the upper left of the frame. The implied action and bright sunburst in the lower right balance the top-heavy upper left.

Canon 70-200 F2.8 lens, F16, 1/60 sec. E-100VS

**The picture above** is all about shape. There are squares, rectangles, a diagonal line, and a circle enclosing several triangles. When composing a picture, I envision the scene as simple shapes like in the sketch above. Here the scene is distilled down to basic two-dimensional shapes that need to be organized within my viewfinder. The elements are organized so the diagonal roof line and triangle enclosing the circular window in the lower right balance the window in the upper left.

**Windows, Berchtsgaden, Germany**

Canon 100-400mm IS lens, F16, 1/2 sec. 81A warming filter, E100VS

**Winter silhouette, Louisville, KY**

# NATURAL LANDSCAPES

## THE CLASSIC LANDSCAPE

At some point in time, every photographer has probably taken a landscape photograph. Loading up the family car and heading off to vacation in a wilderness area or national park is an American tradition. Unfortunately, the typical snapshooting tourist seldom returns with quality photographs. A good landscape is not an accident; it requires the deliberate coordination of several factors.

The first step is to identify your subject. In other words, find the most interesting feature of the landscape. Simplicity is the key; frame only the elements accentuating the subject. Once you've found an appropriate subject, lighting is the next consideration. Scout for subjects and locations during the middle of the day so you can return when the lighting is best. Mood is determined by the way natural light interacts with the elements of line, shape, form, texture, and color. A soft misty day evokes a gentle quiet mood while storm clouds say drama and power. Morning and evening light lends a pleasing warm color balance to your images and creates the shadows necessary for the illusion of depth in a two-dimensional picture. Placing subjects off center is another way to increase the perception of depth.

As previously discussed, don't overlook the importance of depth of field as a creative consideration. Some books tell

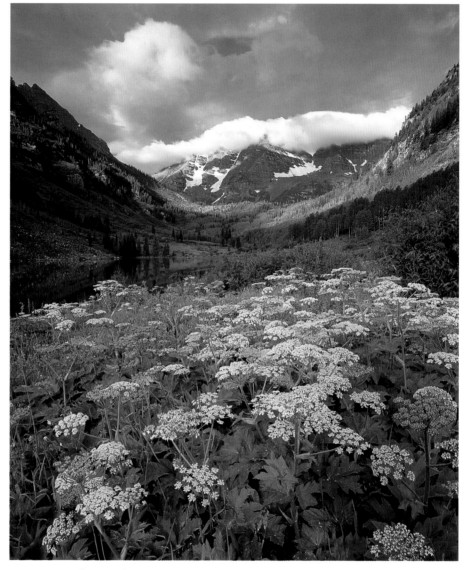

**Cow parsnip and maroon bells, Aspen, CO**

**Here is another** wide-angle landscape with the elements of foreground, middle ground, and background. The white cow parsnip is the dominant foreground element and leads the eye into the picture. The lake and valley are the middle ground, and the mountain peak is the background. Again, layers create interest and the illusion of depth.

Canon 17-35mm F2.8 lens, F16, 2 sec. polarizing filter, E-100VS

Dune primrose and sand verbena, Anza Borrego State Park, CA

**This traditional wide-angle** landscape embodies the classic elements of foreground, middle ground, and background. The white Dune Primrose catching morning light in the very near foreground is the dominant element and leads the eye into the picture. The purple clumps of Sand Verbena are the middle ground, and the distant mountain is the background. This layering of elements is visually interesting and creates the illusion of depth.

Canon 17-35mm F2.8 lens, F16, 1 sec. polarizing filter, Velvia

Appalachian Mountain ridges, Great Smoky Mountains National Park, TN

**In this image** a typical background element is used as the main point of interest. From an aerial perspective, distant objects are bluer and hazier from opaque particles in the atmosphere. Our mind automatically associates muted colors and overall blueness with distance.

Canon 70-200mm F2.8 lens, F16, 1/15 sec., Velvia

you its okay to have out-of-focus foregrounds and backgrounds. I disagree completely. Unless there is a clear-cut reason for doing otherwise, the entire image from the closest detail to the farthest object should be in sharp focus. Of course, there are exceptions; scenes fading into distant fog or similar atmospheric conditions come to mind.

Consider your landscapes in terms of three sections: foreground, middleground, and background. Foregrounds very close to the camera carry a lot of weight, so choose near objects very carefully. Objects in the foreground dominate because of their proximity and sharpness of fine detail. An effective technique is to get in close on the foreground object with a wide-angle lens, and then let the wide angle of view encompass the rest of the scene. Subjects in the distance are less colorful and less sharp due to the effects of atmospheric haze, and our mind automatically interprets this as distance. By eliminating any immediate foreground,

a middle-ground photograph places the primary subject into context with the surrounding environment. A word of caution: Don't let the main subject get lost among competing elements in this situation. The background section highlights distant elements. In some scenes the background is only a secondary feature upon which we portray our subject, and other times it is the dominant feature. Combining the layering effect of foreground, middle ground, and distant background is a strong way to create an interesting picture with the illusion of depth.

## STRETCHING AND COMPRESSING PERSPECTIVE

By definition, perspective refers to the relationship of objects within a photograph. All objects within a scene have relative size and distance between them. A 50mm lens is

**Canon 17-35mm F2.8 lens, at 28mm, F16, 1 sec., Velvia**

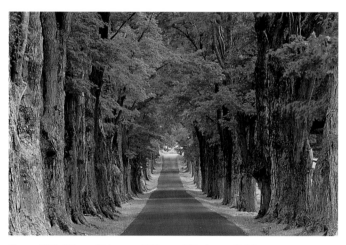

**Canon 100-400mm IS lens, at 200mm, F16, 1 sec., Velvia**

**Employing different focal lengths** and camera-to-subject distances, these two images were framed as similarly as possible. In the wide angle view, the distance and spacing between the foreground trees and background is greatly stretched. Note the apparent huge spacing between the foreground trees. Moving back about 50 yards, the second view was made with a 200mm lens. Now the trees appear compressed to the point of nearly touching one another.

**Tree-lined driveway, Louisville, KY**

often referred to as a normal lens because it reveals a normal perspective between objects. Looking down a picket fence with a normal lens, the spacing between the slats is normal; neither stretched nor compressed.

Wide-angle lenses have less magnification than a 50mm lens, which exaggerates the distance between foreground and background objects. A wide-angle lens reduces the size of everything, especially the background. This greatly expands the apparent perspective between near and far objects. In effect, this shifts emphasis to the foreground. Objects in the foreground appear larger than normal and distant objects seem smaller than normal. Creatively using the relative size of near and far objects is another way of fooling our brain into perceiving depth in a two dimensional photo. If you want to create an image with maximum depth, select a wide-angle lens and move in very close to your subject.

A telephoto lens is an ideal tool for isolating details. I like using them to extract smaller, intimate views from the overall landscape and to compress perspective. A telephoto lens has greater magnification than a 50mm lens, which alters normal depth perception and compresses the apparent distance between objects. Longer lenses appear to flatten or stack elements together and the foreground and background appear closer together than normal. If you want the appearance of stacked elements and reduced depth, back up and shoot the scene with a telephoto lens.

Switching focal length and camera position effectively controls the apparent distance between objects in a picture. Changing only the focal length changes the image size, but does not change the perspective.

Canon 17-35mm F2.8 lens, at 24mm, F16, 1/4 sec. polarizing filter, Velvia

Canon 70-200mm F2.8 lens, at 100mm, F16, 1/4 sec. polarizing filter, Velvia

**In the first view** a wide-angle lens includes a prominent tree in the foreground. This view appears stretched with great depth between the single foreground tree and birch grove in the background. In the next view, I switched to a short telephoto lens and changed shooting position a bit. Here the trees appear flattened or compressed with a reduced feeling of depth.

Paper birch trees, South Woodstock, VT

**Reflected colors, Merced River, Yosemite National Park, CA**

**The sunset colors** reflecting among the flowing shapes and forms in the rapids create a sensual abstract. Using a long telephoto lens, I cropped out al distracting details. The flowing shapes, colors, and textures create a dynamic abstract when removed from the context of their surroundings.

Canon 100-400mm IS lens, F5.6, 1/4 sec., E100VS

## ABSTRACTS & PATTERNS

On a subconscious level we expect cameras to record images in a realistic way. It's not a problem, but at some point you may view your images as too documentary. Breaking away from the shackles of traditional imaging challenges your creativity by teaching you to see differently. Exploring abstracts and patterns is an alternative and fun way of seeing the world. By definition, an abstract photo is not a recognizable portrayal of a subject. The key approach is to move in close and isolate small parts of the whole scene. The goal is to isolate and reveal the artistic design found within the larger scene or subject. A telephoto lens is usually best, but any focal length can work depending on the situation. An abstract landscape can be any subject matter, and of any size from mountainsides to tiny details on a flower.

Since an abstract image doesn't need a recognizable subject, the rules of composition go out the window. However, a good sense of design is still critical. An abstract image is all about arranging color, pattern, shape, tones, and textures into patterns that create a pleasing image. There really is no right or wrong way to create an abstract; the final image either works or it doesn't. Abstract designs are very subjective and very personal, allowing great leeway in personal expression. You'll become a better photographer by training your eye to see abstracts.

Patterns are everywhere; they can be part of a larger scene or in abstract form as pure pattern. The natural world abounds with many similarly shaped elements that form patterns. Unfortunately, in our quest to make realistic photos we often overlook patterns. Success with patterns is simple: extract the graphic design or pattern from a scene by eliminating all other extraneous elements. Developing an eye for abstracts and patterns requires practice and a willingness to experiment. Learning to see in this way seems frustrating at first, but your overall photography skills will improve as a result.

**Abstract Christmas lights**

**Placing a strand** of Christmas lights behind a small cut-glass dish created this abstract view. The lights were rotated while observing the results through a macro lens. A wide-open aperture was used to keep the lights totally out of focus behind the glass. When creating an abstract, you don't always need a recognizable subject.

Canon 180mm macro lens, F3.5, 4 sec. E-100VS pushed (1) stop

**Dunes at sunset, Death Valley National Park, CA**

**Here a strong pattern** is found among the repeating shapes of the dunes and their shadows cast by evening sunlight. Extracting the dunes from the surrounding mountains was simple with a telephoto lens. The pure pattern in this picture creates an abstract view of a commonly photographed area.

Canon 100-400mm IS lens, F16, 1/8 sec., polarizing filter, E100VS

## FLOWERS & PLANTS

Flowers and plants are marvelous photographic subjects. The abundance and proliferation of species offers an ever-changing colorful landscape. From right in your own backyard to the most remote location on the planet, exploring the color, shape, form, and texture of flowers and plants is limited only by your imagination. Making photographic sense out of the staggering array of sizes, shapes, and colors may seem overwhelming. Your equipment selection will dictate your approach to some degree. At home in the backyard I might use one macro lens, but in the Texas hill country among vast fields of flowers and plants, many lenses can be employed.

I usually begin a shoot looking for three types of shots: close-up, mid-range, and wide-angle. Obviously, every flower or plant won't lend itself to all three strategies, but it's wise to carefully investigate each situation with these options in mind. When going in close on flowers or plants, look for interesting detail, color, or pattern to separate from the surroundings. A close-up approach challenges your observational skills and your ability to locate small detail among the visual chaos. Keep it simple: make sure the viewer's attention stays focused on your subject. Short and medium telephotos are perfect for isolating small subjects. Use a large aperture (F2.8-5.6) when you wish to separate the subject from the background and stop down to small apertures (F11-F22) when great depth of field is required.

Cropping tight on a larger section of the landscape is a mid-range photo that shows the subject more in context with its surroundings. This can be any broader view, but usually includes much less than a grand sweeping landscape. A mid-range photo could be a group of flowers and another contrasting element, such as a tree, whereas a close-up might feature a single flower or two. The wide-angle landscape is simply the grand vista. It shows the scene in its entirety. Get close and frame plants or flowers in the foreground and let the wide-angle lens take in the rest of the scenery. A wide-angle view generally requires great depth of field to ensure all the elements are sharp from near to far. Stopped down apertures around F16-F22 are commonly used in wide-angle shots to ensure sharp details from near to far.

Generally, flowers and plants are best photographed in overcast light. Avoid shooting in direct sunlight. Soft over-

**Double flowered bluebonnet, Texas hill country.**

cast lighting reduces contrast preserving the fine details and delicate nature of flowers and plants. Unless the subject's color is a subtle pastel, I prefer to use an 81A-warming filter for most overcast situations. When it's sunny and you need overcast for small subjects, use a diffusing panel to soften the lighting. Consider using a polarizing filter even on cloudy days to remove the shine from vegetation. If wind is a slight problem, the polarizing filter will only worsen the situation. It can nearly quadruple the length of your exposure, use it when the wind is dead calm or when the lens aperture can be opened up.

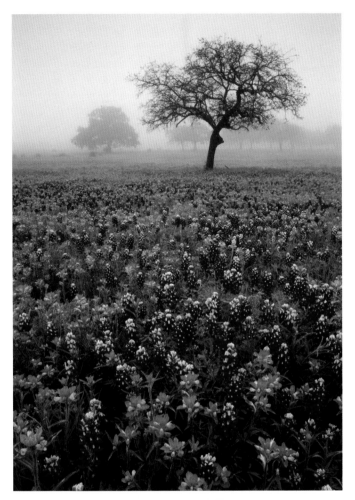

**Field of paintbrush and bluebonnets, Texas hill country.**

**These three images** were all made the same day. This series illustrates three approaches to flowers and plants: close-up, mid-range, and wide-angle. In the wide-angle scenic, the camera was placed close to the nearest flowers to emphasize foreground details. The wide-angle captures an intimate view of the foreground in context with the overall scene. During the harsh light of mid-day I used a diffuser to soften the light and switched to shooting close-ups. For this close-up, a telephoto lens was used at wide open aperture (F5.6) for shallow depth of field, thus isolating a single flower among many. A point of view was selected so the blue flower heads were aligned against an out-of-focus red wash of color. For the mid-range view, I really liked the filtered evening light beneath the trees. Here again a telephoto lens was used to frame only the area of interest. Carefully cropped, the flowers, trees, and sunlight make a pleasing image in limited context with the surroundings.

**Double flowered bluebonnet, Texas hill country**

Canon 100-400mm IS lens, at 400mm, F5.6, 1/250 sec., E100VS

**Paintbrush beneath trees at sunset, Texas hill country.**

Canon 100-400mm IS lens, at 100mm, F16, 1/30 sec., E100VS

**Field of paintbrush and bluebonnets, Texas hill country.**

Canon 17-35mm F2.8 lens, at 28mm, F22, 6 sec., E100VS

**Paintbrush beneath trees at sunset, Texas hill country.**

# URBAN LANDSCAPES

## CITIES & TOWNS

Photographing an urban landscape is much the same as working with natural landscapes. Scout the area ahead of time and once an interesting subject is located, figure out when the lighting will be best. Upon arrival in a city or town, check local bookstores and newsstands for postcards and books highlighting the city. The most famous landmarks are always well represented. The idea isn't to copy what's already been done; you're just looking for locations and good points of view. Strive for something visually different and better than what's been done before. If time is limited, go for the visual icons first and work lesser-known subjects later.

The essence of a town or city is best captured in the architecture of its buildings and the details of daily life. Experiment with different perspectives and different focal lengths. In narrow city streets, wide-angle zooms offer great flexibility for capturing whole buildings and zooming in on details. All conventional lenses exhibit perspective distortion when aimed up or down. Wide-angle lenses exaggerate this effect known as keystoning, where buildings appear to lean inward and converge near the top of a picture. Unless your camera is level, there is distortion. One solution is to back up and shoot with a longer lens when room permits, or go to higher ground and shoot from a window or rooftop so the lens isn't tilted upward. Distortion isn't always a bad thing; it can be creatively used to emphasize the towering quality of skyscrapers. The best solution for eliminating distortion is to employ a perspective control lens like Canon's 24mm tilt/shift lens, which permits the lens to shift its view upward to encompass the top of a building while the camera remains level.

Each city has its own distinctive architecture and details of everyday life. Telephoto lenses are the perfect tool for

**Eiffel Tower, Paris France**

**Before arriving** in an unfamiliar city, a little homework saves a lot of time and energy running around looking for subjects. Create a list of icon landmarks that you find visually interesting and wish to photograph. Then scout these locations during the middle of the day, making notes on when to return for the best light. Here the Eiffel Tower was photographed about an hour after sunrise when the clouds finally cleared.

Canon 28-135mm IS lens, F16, 1/4 sec., polarizing Filter, Velvia

Tour boat on Seine River and the Louvre, Paris, France

**I usually prefer** to shoot early in the morning or late in the evening, but in this instance midday lighting was excellent and the timing was just right as a tour boat passed in front of the Louvre. As the boat was approaching I quickly framed the Louvre and waited until the boat entered the scene and then snapped the image from atop a tripod. There is a lot happening in big cities; keep your eyes open and be prepared to shoot quickly. When traveling on foot, keep a camera mounted on a small tripod so you're ready for unexpected events.

Canon 17-35mm F2.8 lens, F11, 1/60 sec., Velvia

Seattle skyline at last light

**A good clean skyline image** is a compelling portrait of a city. Here an elevated viewpoint offers a commanding view of Seattle just before the sun dips below the horizon. Always check your maps and speak with local residents concerning the whereabouts of elevated parks and overlooks. When a high viewpoint can't be found, change strategies and go low. Many cities are built around rivers and large bodies of water that offer unobstructed and compelling views of the city. As usual, early morning and late afternoon offer the best lighting conditions.

Canon 70-200mm F2.8 lens, F16, 1sec. Velvia

isolating building details or compressing a series of building facades. Train yourself to see the details. From the repeating pattern of a fence, to the peeling paint on windows and doorways, small details extracted from the larger scene make interesting images.

A bubble level is useful for ensuring the camera is level up and down and not leaning to either side. Warming filters should be used the same as with natural landscapes when working in the shade or overcast lighting. Tripods can be a hassle in large cities and towns, but without them you're stuck using wide-open apertures and relatively short lenses. Check local ordinances to make sure tripods are permitted on busy sidewalks. Pay very close attention to your exposures when photographing light- and dark-toned buildings. Nonaverage subjects easily fool your camera meter into gross over or under exposure.

A dramatic icon is the city skyline. Scout for a location that offers a clear view of the city and then decide what

time of day offers the best lighting. Get up high for commanding views, or get down low and incorporate reflections on rivers and lakes. Get up early and stay out late; dawn and dusk are the best times for skylines. Often there is color in the sky even when the weather is much less than perfect.

**Baskets at the market, St. Remy de Provence, France**

**Shoot the major landmarks** first, but don't forget to look for detail shots telling the rest of the story. Once you've captured the major icons, visit local markets, side streets, and city squares looking for interesting details. Your slide show or photo album will be much more interesting when you include a good number of smaller subjects linking the larger scenes.

Canon 90mm tilt/dhift lens, F16, 1/15 sec., 81A warming filter, Velvia

**Colorful fabrics in outdoor market, Avignon de Provence, France**

**A street vendor** gave me perfect directions to these baskets upon explaining to her what I was hoping to photograph. Had I not asked, I would have never found these baskets tucked away in a shaded alley. Often detail shots are the most interesting and offer more opportunities to express our inner vision and creativity.

Canon 90mm tilt/shift lens + 1.4X teleconverter, F16, 1 sec. 81EF, warming filter, Velvia

**In the first image** a conventional 24mm lens was used and the camera tilted upward to include as much of the building as possible. When tilted upward, all conventional lenses distort straight lines, which results in buildings that appear to be leaning and converging (keystoning) at the top of the frame. In the second view a 24mm tilt/shift lens captured the same image without perspective distortion. Here the camera remained level and the lens is shifted upward to incorporate the same view as a conventional lens.

**Building photographed with conventional wide-angle lens tilted upward**

**Building photographed with perspective control (tilt/shift) wide-angle lens**

## FIREWORKS

Every July 4th Americans flock to various locations around the country to witness the spectacle of an aerial fireworks display. These colorful and impressive displays are wonderful photo opportunities when keeping a few basics in mind. The first concept to grasp is that fireworks require a time exposure much longer than most realize. Several seconds elapse from the instant a rocket is launched until the fiery explosion fades.

Capturing the entire action sequence means the shutter must be left open for at least a few seconds and often much longer. Don't be fooled into shooting with your lens wide open, this will only cause overexposure. My base aperture setting for an ISO 100 film is F11 and then I vary the length of the time exposure from about 4 seconds to a minute. Like most night photography, high-speed film is not required. The exact time exposure varies greatly depending on what other lighted structures are included such as bridges, floodlit buildings, and skylines. When you include other lighted structures, there are essentially two exposures taking place: one for the fireworks controlled mostly by lens aperture, and another for the lighted structure controlled by the length of the time exposure and aperture selected for the fireworks. Obviously, a tripod is required to steady the camera during a lengthy exposure. A cable release is advised so you won't be touching the camera while tripping the shutter.

Include some foreground or other scenery when framing fireworks; isolated bursts in a black sky are rather uninteresting. Including city skylines, statues, or bridges lends a sense of place to your fireworks pictures. If you are near a city skyline on a lake or river, frame your shots to include the fireworks and their reflections. Any focal length lens can work; your position relative to the display determines the focal length needed.

Some large firework displays feature thousands of rockets that eventually fill the air with so much smoke that photography is nearly impossible. When possible, pick a vantage point

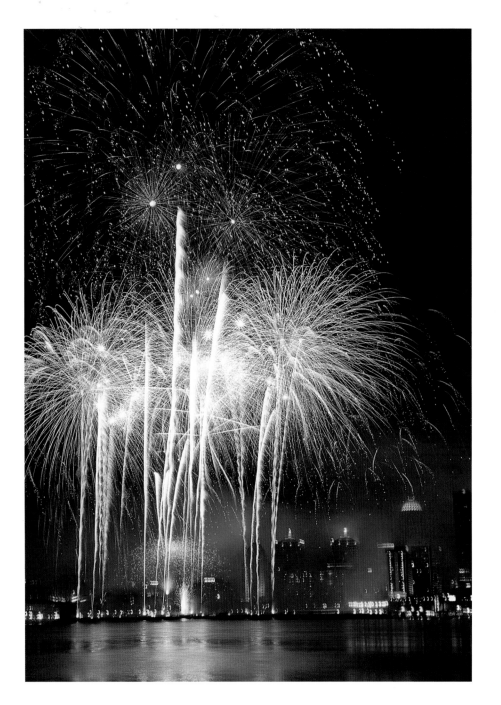

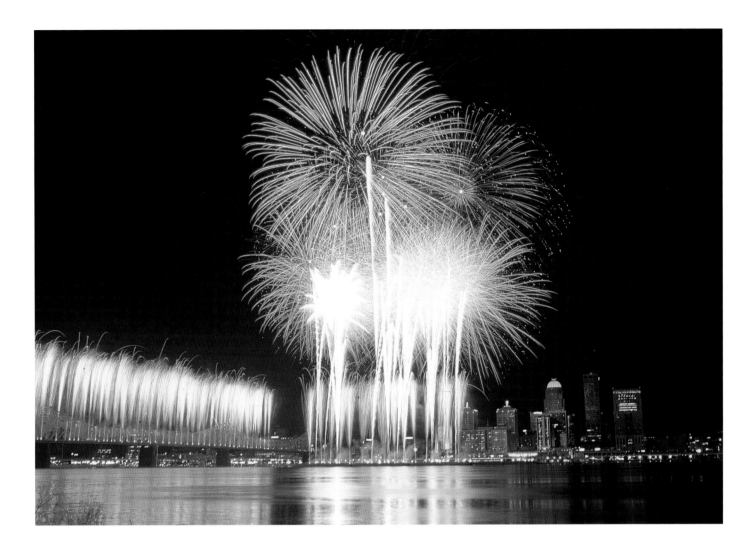

where the wind carries smoke away from your position; or shoot the very beginning of the show before the sky fills with cloudy smoke. The grand climax at the end of many events is often brighter than normal and may require closing your lens down a stop or two. Expose lots of film and vary your aperture a bit; every burst is a unique photograph.

**Don't get caught up** in the awesome spectacle and forget to use various lenses to experiment with different compositions. No two bursts are ever exactly alike, so each frame really is a unique image. At large displays, excessive smoke can be a problem. Get into position early and record the first few rockets while the air is still clear. See the image above. Later in the show, the air can become quite smoky. See the image on page 84. An exposure of F8 at 30 seconds is correct for the skyline and provided ample time for many rockets to be launched.

**Thunder over Louisville fireworks celebration, from across Ohio River in Indiana**
Canon 28-135mm IS lens at F8, 30 sec. Velvia

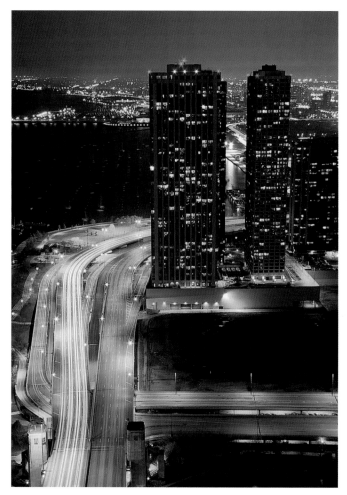

**Traffic trails looking south on Lakeshore Drive, Chicago, IL**

**Floodlit Louisville city hall, from Jefferson Square, Louisville, KY**

**A rooftop vantage point** offered a commanding view of rush hour traffic on Chicago's famous Lakeshore Drive. In this situation I stopped down 1 stop from my base exposure of F8 at 30 seconds to keep the shutter open longer, allowing more traffic to pass. Fuji films are well known for shifting somewhat greenish with long exposures on dark skies. If you find this objectionable, adding a 10-20cc magenta filter greatly reduces the problem.

Canon 28-135mm IS lens at F11, 90 sec., Velvia

**In this busy scene** with a floodlit building surrounded by various other lights I couldn't rely on base exposures. The solution: spot meter the most important element (the floodlit building) with a telephoto lens and set exposure from those readings. An exposure 1 stop brighter than indicated by the meter turned out to be the best overall exposure. Each floodlit building is a unique situation, so spot meter the well-lit areas of your subject for accurate exposure.

Canon 28-135mm IS lens at F16, 60 sec., Velvia

## NIGHT PHOTOGRAPHY

Most nature photography ends with the arrival of darkness; however, this is when many urban landscapes are just beginning to come alive. It's usually assumed high-speed film and fast lenses are required, but in most cases the lenses you already own should work. A fast lens is of little benefit since most urban landscapes need to be stopped down to around F16 for adequate depth of field. Zoom lenses are convenient and offer great flexibility in framing and you can even zoom your lens during a long exposure. Since most scenes require at least several seconds for exposure, a tripod is essential for holding the camera still. Once your camera is supported on a tripod you are free to use any film, aperture, and exposure combination. Nearly any film works, but rarely is film faster than ISO 100 required. I use daylight balanced films, preferring the warmer tones.

No special camera is needed; a simple SLR capable of manual exposure and a bulb setting is quite effective. Modern electronic cameras can drain quite a few batteries with repeated long exposures, so bring plenty of batteries or use a camera with mechanical settings for the shutter and aperture controls. Of course, a cable release or electronic release is advised so you're not touching the camera when tripping the shutter.

Night photography intimidates a lot of photographers, when really it's quite simple. The first hurdle is getting enough light on the film for proper exposure. The most common mistake is not exposing long enough. Fortunately, we can estimate correct exposure for many common subjects. City skylines, aerial firework displays, and car trails all require relatively similar exposures.

Below are some basic starting points for typical situations using ISO 100 film at F16. For best results don't be afraid to experiment with exposures well above and well below these starting points.

| ISO 100 @ F16 | |
|---|---|
| City at Night | 1 Min. |
| Traffic Trails | 30-60 Sec. |

Cities, towns, and traffic trails record best about 30-40 minutes before dawn and 30-40 minutes after sunset. For a starting point, manually set the time and aperture listed above. Start shooting when a spot meter reading from the sky indicates a similar exposure. To bracket exposure, I expose once when the sky is a little brighter than my base exposure, one right on, and one when the sky is a little

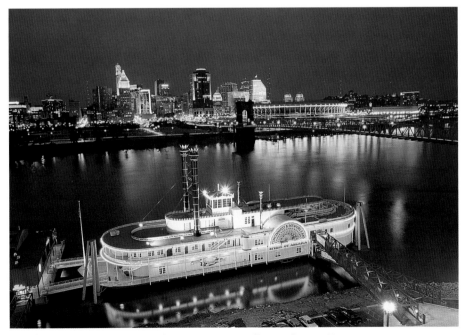

**Ohio River and Cincinnati skyline from Covington Landing, Covington, KY**

**This view** of the Cincinnati skyline clearly illustrates how much color is still in the sky 20-40 minutes after the sun goes down, even on an overcast evening. My base exposure for skylines with Velvia is F8 at 30 seconds. Setting up just at sunset, I manually set my base exposure and waited as the sky darkened and a spot meter reading from the sky indicated an exposure of F8 at 30 seconds. With this method the sky and city lights are both properly exposed and the sky is more interesting when it has color.

Canon 28-135mm IS lens at F8, 30 sec., Velvia.

darker. Every large city has many floodlit buildings that make interesting subjects. I usually don't estimate exposure for floodlit buildings, preferring instead to spot meter the most brightly lit areas for very accurate exposure. Go with your meter reading on average-toned buildings and increase or decrease exposure to achieve lighter or darker tonalities. Dusk and dawn are again the best times, and remember to shoot when the sky exposure is nearly the same as the exposure for your floodlit building. Influenced by the source of illumination, floodlit buildings may have rather odd color casts. Tungsten and sodium vapor lighting have yellow/orange casts and mercury vapor a blue/green cast. I don't usually correct for these color casts, preferring to let the striking color contrast against a sky that has some color.

Traffic trails are an interesting way to record streaking headlights and taillights on passing automobiles. Once again dawn and dusk are the best times when there is still color in the sky. Look for an elevated viewpoint above a busy road, intersection, or highway where there's a lot of traffic. When including floodlit buildings, be sure to expose for them and not the base exposure settings listed above. The best time is early spring and late fall when rush hour traffic coincides with dusk. When there are gaps in the flow of traffic, hold a black card in front of your lens until other vehicles approach your scene, then remove the card to resume your exposure as desired.

## INTERIORS

This first step is finding the most interesting feature defining the essence of a building's interior. This can be any composition from a huge auditorium to a single room, or small desktop feature. Indoor lighting has unique color qualities that must be considered and corrected for quality results. Interior lighting is usually quite dim and tripods are mandatory for exposures often exceeding 30 seconds. (See page 34 for information on reciprocity failure.) Window light is my favorite light source, but not contrasty sunlight shining through a window. Scout interiors at different times of day and shoot when the lighting is most flattering. My favorite light is soft, indirect light from a window not receiving direct sunlight. Indirect lighting is a bit cool and benefits from an 81A warming filter when working with color slides. You can also turn on room lamps in conjunction with natural light after replacing the tungsten bulbs with photo bulbs that emit daylight-balanced light.

A single flash unit is not good as the primary light source for illuminating a room; the lighting falls off too quickly and looks unnatural. Do consider fill flash, as it dramatically improves the quality of most lighting. Set your flash compensation dial to about minus $1^1/_2$ or minus 2 stops in TTL mode and your flash should blend seamlessly with the natural light to open up darker areas.

Tungsten lamps common in many interiors are another lighting option. With daylight balanced film, these lamps produce very warm amber light. In some cases the warmth matches the character of a room and other times it's overpowering and needs correcting with an 80B filter. Keep in mind a color correction filter makes already long exposures even longer. Of course you can always switch to tungsten film, which doesn't require corrective filters. When using tungsten film or an 80B filter with daylight film, close or cover any windows to keep daylight from entering the room or work at night. Any daylight leaking into the scene will record extremely blue. Fill flash isn't correctly color balanced for tungsten film or for use in combination with an 80B filter and daylight film. To correct for this, attach an amber gel (Rosco #3401) to the flash head to color balance light from your flash to match the amber light of the tungsten bulbs.

Many interiors of commercial buildings are lit with fluorescent lights that produce green light on daylight films. Fortunately, filters are available to correct this strong green cast. The most common is an FLD filter or you can use a 40CC magenta filter for very similar correction. When using fill flash, attach a green gel (Rosco #3304) to the flash head to color balance light from your flash to match the green light of the fluorescent lamps.

When setting up, use a bubble level to make sure your camera is level in every direction, otherwise walls appear to converge and appear skewed. Watch for troublesome reflections on glass, glossy paint, and mirrors. Make sure your own reflection isn't showing in mirrors located within the scene. Mixed lighting is nearly impossible to correct properly with slide films. In this situation try print film, it can be easily corrected later when printed.

Canon 17-35mm F2.8 lens, F16, 6 sec., uncorrected fluorescent lighting, Velvia

Canon 17-35mm F2.8 lens, F16, 10 sec. + 40CC magenta filter, Velvia

**The museum interior** without corrective filtration clearly illustrates the green cast of florescent lighting on color slide film. In the corrected version, a 40cc magenta filter completely eliminates the green cast, producing a natural and pleasing result.

Camp Breckinridge Museum and Arts Center, Morganfield, KY

**This beautiful cathedral** is primarily illuminated with tungsten lighting. Therefore an 80B (blue) filter was used in the first version for correct color balance. Although accurate, the feeling is cool and a bit less inviting than the tungsten version. In this situation, tungsten lighting complements the architecture and lends an inviting feeling to the church.

Cathedral Basilica of the Assumption, Covington, KY

Canon 24mm tilt/shift lens, F16, 8 sec. + 80B filter, Velvia

Canon 24mm tilt/shift lens, F16, 4 sec. (uncorrected) Velvia

## FESTIVALS & EVENTS

To effectively photograph festivals and events, leave your tripod at home and adopt a photojournalistic approach. Tripods are too slow and cumbersome in crowded situations where handholding your camera is the only way to stay mobile. An ability to think on your feet and adapt to changing situations is a great asset for run-and-gun picture taking. Covering an outdoor event such as a parade is similar to wildlife action photography, where a good photojournalist anticipates the action and slips into the right location in time to capture the decisive moment. Obtain a schedule of events so you at least know when and where events are scheduled to occur. Try to get a media pass; you'll enjoy much greater freedom and access than is extended to the public. Sponsors and organizers of smaller events are often willing to trade images taken during the event in exchange for a media pass. Make sure you can deliver quality images on color slide film before bartering a trade, and make sure you follow through and deliver what you promise.

There is no one right film for all occasions; however, at least a moderate film speed is recommended for handholding and stopping action. Normally ISO 100 film pushed one stop is sufficient for bright overcast or sunny situations, especially when combined with image stabilized lenses. Opt for films in the 200-400 ISO range when using slower non-stabilized lenses or when the light is fading at the end of the day. Select wide-open or nearly wide-open apertures to ensure fast shutter speeds for eliminating camera shake and stopping active subjects.

Two camera bodies with zooms easily handle most of my event assignments. Attached to one camera body is a Canon 28-135mm IS that I've used exclusively on more than one full-day assignment. This one zoom is great in crowded situations where it's wide enough to let me work up close with a variety of subjects and yet fill the frame with close subjects. My other body has a Canon 100-400mm IS zoom lens that provides the extra reach when subjects are distant or I need to isolate details. Event photography is the only time I advise using a camera strap for hanging cameras on your shoulder. For nature work a camera strap is always getting in the wa., However, in this situation a strap conveniently positions the camera so its ready without holding the equipment in your hands all day. The same goes for camera bags. Normally I suggest backpack style bags for outdoor work, but here again the speed and mobility of a shoulder bag is superior.

Change your shooting position often. If you stay in one location, your pictures will all look the same. Stay ahead of the action, keep moving to new locations and new perspectives. Consider using fill flash to reduce harsh shadows when subjects are in direct sunlight. When simultaneously dashing around, composing, and handling the mechanics of the camera, there isn't time to carefully study what's in your viewfinder. Shoot a lot of film because failures are inevitable.

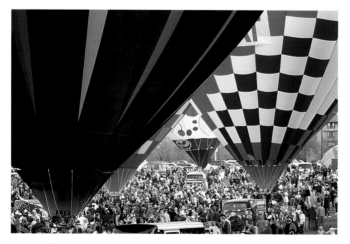

**Great Balloon Race, Louisville, KY**

**Like everyone else** at this festival, I was a bit let down with the weather, realizing the balloons would look dreadful against an overcast white sky. I ditched my preconceived notion of a blue sky filled with colorful balloons. Scrambling up a small hill on the edge of the field provided enough height to shoot over the crowd and put me far enough away to utilize a telephoto lens to fill the frame with color. Thinking fast and adapting to changing situations is your best asset in these situations.

Canon 70-200mm F2.8 lens, at F5.6, 1/15 sec., Velvia + 81A warming filter.

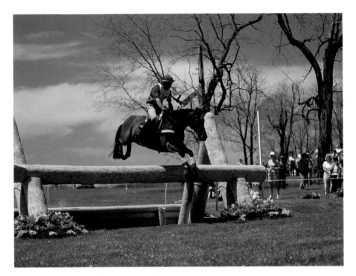

**Jump at the Kentucky Horse Park, Lexington, KY**

**The action** at this jump is predictable since every horse on the course attempts to clear this hurdle. In situations like this, simply set up your gear and wait for the action to come to you. When the action is predictable, look for two or three alternative locations for variety in your shots.

Canon 70-200mm F2.8 lens, at F5.6, 1/1000 sec., Provia pushed 1 stop

**In order to eliminate** a terrible background, I was forced to crop this dancer very tightly. I made a few shots with a wide-open aperture and a fast shutter speed, then reversed tactics and stopped the lens down to F22 using a slow shutter speed. Viewing the processed images at home on my light-box, it was clear the abstract versions were far more effective in depicting the dancer's movement. Once again this illustrates the necessity for staying flexible and solving problems quickly on location.

Canon 100-400mm IS lens, F22, 1/15 sec., Velvia

**Native American dancer at powwow, Bardstown, KY**

# FLASH TECHNIQUES

## THE BASICS

Small portable flash units have revolutionized 35mm SLR photography, freeing us from the limitations of natural light. Millions of amateurs own cameras with built-in flash, yet flash is one of the least understood facets of photography. Most don't understand why shots of their friends have that familiar overexposed deer-in-the-headlights appearance.

A basic understanding of flash photography requires that you learn and work within the quirky characteristics of flash illumination. Light from any single camera-mounted flash has two inescapable characteristics. Number one, light from a small light source is harsh. Flattering portraits of people are usually made with large light sources, therefore don't expect a pinpoint light source to provide flattering light. Relative to subject size, small light sources produce harsh light and large light sources produce soft light. From ten feet away a single flash unit is a tiny light source when your subject is a person. The same flash unit ten inches from a small insect is a relatively large light source. A flash mounted in the camera hot shoe compounds the harshness of a small light source. Mounted close to the axis of the lens, the light is terribly unflattering and often produces red eye, causing your subjects eyes to glow like some alien life form. Moving the flash off camera a few inches above the axis of the lens eliminates most red eye. See Really Right Stuff (www.reallyrightstuff.com) and Wimberley (www.tripod-head.com) for excellent off-camera flash brackets. If you own a point-and-shoot camera with built-in flash, have your subjects look just over your shoulder and not directly into the camera to help reduce red eye.

To improve the quality of your indoor flash pictures, try bouncing light off a large white surface. Walls and ceilings work fine as long as they are white. Flash picks up a color cast when bounced off colored walls and ceilings. Bounced flash is less harsh because the light expands tremendously before reaching the ceiling where the large illuminated area is then reflected downward on the subject, creating an effect similar to that of a much larger light source. Keep in mind that a lot of flash power and/or distance is lost when light is bounced. Use a wide aperture and stay reasonably close to your subject. Your automatic flash metering will compensate as long as you don't exceed the flash's maximum distance range. When bounced, light must travel further to reach the subject and power is lost due to light scattering.

The second characteristic of all light sources is governed by the laws of physics and is referred to as the Inverse Square Law. This law states that light from any single-point light source diminishes according to the square of distance it travels. In simple terms, this means the power of your flash diminishes very quickly with distance. Logically you would think that doubling the distance to your subject would reduce the light reaching that subject by one half. It's much worse; light reaching the subject is reduced to only one forth. In terms of camera adjustments, you're loosing 2 F-stops of light when you double the distance. The good news is that your TTL (through-the-lens) flash automatically compensates for variations in distance within limits of the flash range. However, no TTL system can correct for light falloff when illuminating subjects at widely spaced distances. Just know that elements only a few feet in front of a correctly exposed subject will be overexposed, and elements a few feet behind a properly exposed subject, will be underexposed. Work around this limitation by keeping subjects at approximately the same distance from the flash. Moving closer to a subject only exaggerates light falloff. The best

**Oranges on table top illustrating "Inverse Square Law"**

**Subject with red eye from built-in flash**

**These oranges** are evenly spaced at 10 inches on a table. Correct exposure was set for the second orange in the line. Located a mere 10 inches closer to the camera/flash, the first orange in the line is clearly overexposed. Just behind the properly exposed orange, the third, fourth, and fifth oranges become progressively darker as light travels further to reach them. The lesson here is to realize that no single-point light source or TTL system can properly expose for widely spaced subjects. To avoid these kind of situations.

Canon 28-135mm IS lens at F16, full flash, E100VS

**Whenever a flash** is located too close to the lens axis there is a risk of getting "red eye" in your photographs. With the flash close to the lens, light enters the subject's eye and is reflected off the retina and straight back into the camera lens. Blood vessels in the retina appear otherworldly in the subject's pupil. Moving the flash off camera and a few inches away from the lens axis usually corrects this situation.

Canon 28-135mm IS lens at F16 with full flash, E100G.

tactic for subjects at varying distances is to back up. To a very limited degree, increasing the distance to all the elements reduces the difference in illumination between near and far subjects.

## FULL FLASH INDOORS & OUT

For candid photos where indoor light levels are low, flash can save the day. Most interior lighting is quite dim and exhibits a strong color cast. Simply set your camera to the required sync speed, and flash quickly eliminates color cast. The quick pulse of light eliminates any need for a tripod, permitting you to freely move about for candid shots. Indoors, flash is capable of freezing movement, such as active children. By definition, full flash means the flash unit provides all the light on a subject. Select the maximum sync speed for your camera and appropriate lens aperture; and the flash automatically supplies the correct amount of light within a given distance range.

The most serious drawback to full flash from a small flash unit is that it's not flattering and shadows are harsh. Some accessory flash units allow the flash to be aimed up or to the side for bouncing off walls and ceilings. This is a good option for reducing the harshness of direct flash illumination. When using bounce techniques, make sure the wall or ceiling is white to avoid picking up a color cast. Most flash accessories sold to soften the effects of flash have very limited usefulness for anything other than small subjects. They fail to make the light source large enough for a significant improvement.

Whether indoors or out, TTL (through-the-lens) flash metering automatically reads the flash reflected from the subject during the exposure, and turns the flash off when correct exposure is achieved. This system automatically compensates as the flash-to-subject distance changes. However, no TTL system can fix the exposure difference between widely spaced subjects. Changing the aperture does not bracket exposure in TTL mode. Within a given range, this automatic feature ensures the same amount of light reaches the subject regardless of aperture selected. When bracketing exposure, vary flash output via the flash compensation dial and not the lens aperture. Refer to your owner's manual for precise directions. Shutter speed has no effect on exposure with full flash. The shutter merely needs to be fully open when the flash is triggered.

Most hobbyists readily compensate their natural light exposures for nonaverage subjects, but seem to forget the need to do the same with automatic flash when illuminating light and dark subjects. Most cameras read flash output much the same as natural lighting so very similar flash compensation is prudent for light and dark subjects. Dial in plus compensation for lighter than average subjects and dial in minus compensation for subjects darker than average.

My primary use of full flash outdoors is to freeze the movement of small active creatures such as butterflies and insects. At close working distances of a few feet or less, an accessory flash can easily overpower bright sunlight. With full flash as the only light source, natural light is of no concern, and a tripod isn't needed. The extremely short duration of the flash easily stops moving subjects and eliminates

**My wife arranging flowers, photographed with available light from tungsten lamps.**

camera shake. It doesn't get much easier. Simply turn on the flash, set the sync speed, pick an appropriate aperture, and you're ready to go about shooting handheld.

**The first image** in this series was made with the dim light from a single tungsten lamp, resulting in a blurry handheld image. The scene exhibits an orange color bias because daylight film isn't color balanced for tungsten lighting. Switching to full flash in the second example, the orange color bias and all camera movement is eliminated. Now a new problem appears in the form of harsh light and heavy shadows from the lamp. This flashed look is unavoidable when using a single flash unit aimed directly at the subject. For more natural results, aim the flash upward and bounce light off a white ceiling as in the third illustration.

**My wife arranging flowers, photographed with available light from tungsten lamps.**
Canon 70-200mm F2.8, at F2.8, 1/15 sec., E100G (Handheld without flash)

**My wife arranging flowers, photographed with direct full flash.**
Canon 70-200mm F2.8, at F2.8, 1/200 sec., E100G (Handheld using direct full flash)

**My wife arranging flowers, photographed with flash bounced off white ceiling.**
Canon 70-200mm F2.8, at F2.8, 1/200 sec., E100G (Handheld using bounce flash)

**My wife arranging flowers, photographed with direct full flash.**

**My wife arranging flowers, photographed with flash bounced off white ceiling.**

## FILL FLASH INDOORS & OUT

I'm surprised at the number of advanced photographers who remain mystified by fill flash. This powerful technique is simply the blending of two light sources during one exposure. The primary light source is natural light and the secondary light source is your flash. During full flash the camera is set at the highest sync speed, but with fill flash, top sync speed is seldom used.

Aperture priority is the best mode for using fill flash. You select the appropriate aperture for the situation and let the camera decide the correct shutter speed. Assuming the subject isn't moving and the camera is supported on a tripod, any shutter speed works. Your flash can fire at any shutter speed at or below it's fastest sync speed. To get started, pretend your flash is turned off and set exposure as you normally do in aperture priority. Next, set the fill flash to auto-

matically reduce flash output by –1½ or –2 stops. Don't confuse this setup with power settings that manually vary the flash output. Manual setting will not work as intended. You want the flash output automatically controlled at your desired setting while in aperture priority mode. Check your owner's manual for exact directions for your system.

Once the flash is set to a substantial minus setting, simply shoot as if the flash was not in use. Fill flash has virtually no effect on the overall exposure. The magic of fill is that it only effects the shadow areas of the image. Even when set at –2 stops, fill dramatically opens up shadowed areas on cloudy days or during indoor situations. Shadows can be quite harsh on bright sunny days. Consider boosting your fill settings to –½ or –1 stop. My standard setting for indoor/overcast lighting is –1⅔ or –2 stops. Fill light adds a beautiful catch light in the eyes of your subject whether

### In this indoor example
I wanted the exposure to be correct for both the window and the curios. The first step was to manually set the outdoor exposure from a spot reading through the window and make one shot without flash. Here the curios are backlit and the white shutter is too dark. Then two additional shots were made at exactly the same ambient settings, but with the addition of flash. In each successive shot I added more flash to the scene by adjusting only the flash compensation settings. In these examles a -1 stop setting successfully brightened the curios and opened up the dark area on the right half of the frame. By adjusting the flash compensation settings, I successfully balanced the indoor and outdoor lighting.

**Curios on window ledge, Victorian House Inn, Smiths Grove, KY.**
Canon 100-400mm IS lens, F11, 1/125, E100VS (No Flash)
Canon 100-400mm IS lens, F11, 1/125, E100VS (Fill Flash at -1 stop)

**Compared side by side,** the sparkle in the eyes of the fill-flashed gorilla (right) is clearly superior. In the version without fill flash (left), the gorilla's dark, recessed eyes are invisible even though exposure is perfect. To fix this problem, flash was set at -2 stops and made exactly the same automatic exposure as the image without flash. Notice how the overall exposure remains unaffected by the addition of the fill lighting. Only the dark areas are lightened. Indoors or out, flash works exactly the same on human subjects.

**Lowland Gorilla, Cincinnati Zoo & Botanical Gardens**

Canon 400mm F2.8 lens + 2X teleconverter, F5.6, 1/30 sec., Provia pushed (1) stop (No Fill Flash)

Canon 400mm F2.8 lens + 2X teleconverter, F5.6, 1/30 sec., Provia pushed (1) stop + (Fill Flash at -2 stops)

shooting inside or out. The idea is to blend the flash seamlessly so the subject looks completely natural and not flashed. Simply reduce the flash exposure to a point well below the natural light exposure and shoot away like normal. If you're in doubt about which setting to use, it's better to err on the side of too little flash. At least the subject won't look flashed.

Unlike full flash, fill does not freeze subject motion or eliminate camera shake. Two exposures are taking place, one for the flash and one for the natural light. If nothing moves, both exposures overlap perfectly as one. Ghosting occurs if there is movement during the exposure. Fill light freezes movement the instant the flash discharges, but the subject keeps moving during the time the shutter is open for the ambient light exposure. The lag time between the flash firing and the shutter closing creates two overlapping images; one blurred and one sharp. Fill flash won't freeze the action of your active kids, but it can greatly improve the quality of images inside and out. As in any normal shooting situation, make sure the shutter speed is adequate for the situation and the let the flash work it's magic automatically.

## EXTENDING FLASH RANGE

A good accessory flash unit should feature a zoom head that varies flash coverage for lenses ranging from around 24mm to about 100mm. Some even cover wide-angle lenses all the way down to 17mm. All is well and good up to about 100mm, but what about flash with longer lenses? Sooner or later you'll want to combine flash with a telephoto lens where distant subjects can easily exceed the maximum range for even the most powerful flash. Lack of flash power isn't the problem. Your flash is wasting power and loosing distance because light is spread over a wider area than needed for a telephoto lens.

What is needed is a way to refocus light from the flash into a narrow concentrated beam thereby increasing maximum range. Thankfully, there are products designed for exactly that purpose. There are two basic designs available. Both refocus light from your flash via a fresnel lens positioned about 6 inches in front of the flash. One design features a rigid boxy unit, and the other is a collapsible three-piece unit that folds flat and weighs only a few ounces. I prefer the collapsible design known as the Better Beamer.

For information go to www.birdsasart.com. Once attached to a flash, either style performs well. The design of the Better Beamer requires far less room in your camera bag and it's significantly lighter in weight. In fact it's so compact it easily fits in a shirt pocket.

A gain in flash power of 2 to 3 F-stops is realized with these devises, which translates into projecting flash over great distances. I nearly always use this set up when employ-

**Flash extender attached to flash above telephoto lens**

**By attaching** a flash projection device (Better Beamer) the useful range of your flash is greatly increased, especially when used for fill lighting. This device is ideal for photographers who already have a large kit and don't want to add more weight in terms of bulky lighting gear.

ing fill flash with telephoto lenses. Using ISO 100 film and fill set for −2 stops, proper fill lighting can be achieved over surprisingly long distances. Unless there is no other way to get the shot, I don't recommend using projected flash as the main light source. A tiny light source so far from the subject is usually too flat and unnatural. Except for increased range, fill flash with a projection device is exactly the same as fill without the attachment. Most projection devices are designed for 300mm and longer lenses. Using a shorter focal length results in a spotlight effect, where only a small portion of the subject is illuminated.

Garage doors illuminated by standard flash.

**Both images** of garage doors were made at identical settings with flash. Clearly, a typical flash spreads light over a larger area than required for the narrow view of a telephoto lens. Light is being wasted when used with a long lens. Here a Better Beamer concentrates light from the flash into a tiny area, translating into greatly increased power and flash distance. These devices are designed to work with 300mm or longer telephoto lenses.

Canon 50mm lens, at F2.8 + 550EX flash with flash zoom head set at 105mm

Canon 50mm lens, at F2.8 + 550EX flash + Better Beamer attached

Garage doors illuminated by flash with Better Beamer.

# CLOSE-UPS

## THE BASICS

Close-ups are not grand scenics; they are the intimate views of details making up the larger view. This kind of photography is appealing because it's easily enjoyed anywhere. An intensely inquisitive photographer with a keen eye can find subjects everywhere. Your own backyard or empty field can be a bonanza when exploring intricate details. Even common household items can be fascinating when the details are magnified. There is no right way or one best lens for all situations. Thanks to interchangeable lenses and versatile accessories, 35mm photography permits various strategies for close-up work. Many find it surprising to learn that high-quality professional close-ups are possible without owning a specialized macro lens. Lenses you currently own can be made to focus closer with the addition extension tubes or close-up diopters. See accessories on page 106.

Handholding your equipment is virtually impossible for close-up photos. As the subject is magnified, so are problems with movement. Your technique can't be too good when steadying your equipment. For consistently sharp natural light images, use a tripod. Choose one capable of spreading the legs for work at ground level. A tripod makes you slow down and lets you study your composition. Handholding limits you to wide-open apertures, fast shutter speeds, and fast film. Even with slow fine-grained film, a tripod permits access to a full range of aperture and shutter speed combinations. Lenses featuring image stabilization technology offer a few exceptions to the tripod rule. Limited close-ups are possible in bright sunlight with relatively fast film. In bright sunlight, I've made professionally sharp images of active butterflies with a handheld 100-400mm IS lens and a 25mm extension tube using pushed ISO 100 film. For the rest of my nature work a tripod ensures critical sharpness.

Close-up photography requires a blend of precise technical execution and aesthetics more than any other photographic endeavor. Plain and simple, a lot of mechanics are involved. You must select the right tools, position the camera in exactly the right place, compose, and set the correct exposure. At the same time you need to make good artistic decisions. Good technique, both technical and artistic, is more important than equipment. Once you've found a subject, placement of the camera is very important. Depth of field is extremely limited; maximize whatever depth of field you have by aligning the film plane parallel to the important subject plane. As magnification increases, depth of field is reduced, and camera placement is even more critical. At 1:1 magnification (total area of scene is approx. 1 x $1^1/_2$ inches) depth of field at F16 is only $^1/_{16}$ inch.

Always use an electronic cable release; don't touch the camera while tripping the shutter or during the exposure. Lock your cameras reflex mirror in the up position before tripping the shutter to eliminate vibrations from mirror slap that reduces sharpness.

Bright blue-sky sunny days are not the best for close-up photography. Soft overcast light is far superior for rendering clear details with rich saturated colors. Details get washed out and lost among the shadows on a sunny day. When its sunny, a white translucent umbrella or diffusion screen is very effective for simulating overcast lighting in the field. When photographing intimate details, don't leave home without one of these devices. See reflectors and diffusers on page 105.

**In the first shot** the skipper's eye is properly focused, but the wing falls out of focus because the film plane is not parallel with the plane of the near wing. In the second view, the tripod and camera were carefully repositioned to make sure the film plane is parallel with the subject's eye and near wing. Even at this relatively wide aperture, the eye and entire wing are sharp.

**Skipper on coneflower, Louisville, KY.**

Canon 180mm macro lens, F8, 1/30 sec. E100VS.

**These two illustrations** clearly show the need for a tripod by comparing the differences in sharpness from handheld camera versus a tripod-mounted camera. I shot numerous frames handheld at $1/30$ second and this frame was the sharpest of the bunch. At this magnification and shutter speed, I'm clearly unable to hold a camera steady enough for a sharp image. In contrast I took one shot of the same flower from a tripod-mounted camera and the resulting image is tack sharp. A close view of the center flower shows how the tripod version maintains a very high degree of sharpness, revealing all the intricate details of the flower.

**Flower arrangement handheld vs tripod**

Canon 180mm macro lens, F8, 1/30sec. E100VS.

**Handheld**

**Tripod**

## CHOOSING A MACRO LENS

A lot has been written about macro lenses and which focal length is best. Most manufacturers offer macros with focal lengths falling into three categories: 50mm, 90-100mm, 180-200mm. All three focal lengths deliver extraordinary image quality. So what is there to debate? Several factors are worth considering when making a purchase. Price is certainly important, but not the most important. For example, a Canon 50mm F2.5 costs roughly $250; a 100mm F2.8 is about $500; and a 180mm F3.5 is $1,200. Price roughly doubles each time the focal length is doubled. Due to the very close working distance and lack of background control, I would not consider a 50mm macro as my workhorse lens for fieldwork. If you are on a tight budget and you only do occasional macro work, a normal focal length macro may suffice.

Most modern macros focus to 1:1 magnification without additional accessories. This simply means a lens fills the frame at its closest focus with a subject the size of one frame of 35mm film. Focal length is worth considering in two important reasons. The first is working distance, which is the distance from the end of the lens to the subject. Telephoto macros produce the same size image further from the subject and that is a great advantage in the field. For example, to fill the frame with the image of a 35mm-film cassette, a 50mm macro lens is only two inches from the film cassette. For the same image size, a 180mm macro is 12 inches from the subject. In the field, the extra working distance is a tremendous advantage. For fieldwork, consider at least a 90-100mm lens. Active subjects seldom allow an approach within two inches, but many creatures will tolerate your

Canon 50mm macro lens, F8, 1/4 sec., 81A warming filter, E100VS

Canon 100mm macro lens, F8, 1/4 sec., 81A warming filter, E100VS

lens at 12 inches. Another advantage of longer focal lengths is realized when lighting tiny subjects with flash or reflectors. Lenses placed only an inch or two from the subject allow practically no room for positioning reflectors or flash units for supplemental lighting. Ask yourself one question. Do I really want to struggle positioning a tripod-mounted camera within a few inches of every small subject?

Selective background control is another huge advantage realized with longer focal lengths. The narrower angle of view simply sees less behind the subject. With telephoto designs, small adjustments in camera position result in big changes to the background. Often the only way to eliminate a messy background is to back up and shoot with a longer lens. Of the three focal lengths discussed, only the longest is supplied with a tripod collar. The added stability, balance, and convenience is more than worth the extra cost. Bottom line, they all work, but the advantages in working distance and background control make the longer focal lengths more useful. Close-up photography in the field demands exacting skills. Longer lenses simply make field work a lot less aggravating and a whole lot more fun.

**Canon 180mm macro lens, F8, ¹/4 sec., 81A warming filter, E100VS**

**Here I made a series** of identical compositions with focal lengths of 50mm, 100mm, and 180mm. The superior background control of the longer lenses is clearly evident. At 180mm, the narrow angle of view sees the least background for the most pleasing composition. In comparison the wider view of the 50mm lens includes too much cluttered background even picking up the overcast sky. The 50mm lens also required such a close working distance that one leg of the tripod extended well beyond the subject.

**Dahlia, Louisville, KY**

**Early morning sunlight** is raking across the first spiderwort flower image, resulting in harsh shadows and uneven lighting. In the second version a diffusing screen was placed just to the left of the flowers to soften the directional sunlight. The result is an image with greatly reduced contrast and soft, open shadows. Note the cooler color balance once the warm light is diffused.

Canon 180mm macro, F16, at 1/8 sec., Velvia

**Spiderwort flowers, KY (without diffuser)**

**Spiderwort flowers, KY (with diffuser)**

## REFLECTORS & DIFFUSERS

Nature photographers have no control over lighting on large scenes, but small subjects are a different matter. Bright sunlight is far too harsh and contrasty for recording the delicate details so important in close-up photography. Overcast lighting gently wraps the subject in beautiful soft light, however it's impossible to shoot only on overcast days. The solution is learning to control light with reflectors and diffusers.

When photographing small subjects in the field, I always carry a diffuser or two for softening direct sunlight. Diffusers are not designed for totally shading a subject. Instead, light passes through the diffusing material, greatly reducing contrast on the subject below. A translucent white umbrella is a perfect ready-made diffuser. Placement of the

**In this comparison** a cowboy is sitting in the shade on a sunny Montana day. I knew the open shade would cause my first image to be very blue, so for the second image an assistant bounced direct sunlight onto the subject with a gold reflector. The added punch of the warm light from the gold reflector is much more pleasing. Although it works here, reflecting harsh sunlight onto softly lit subjects is not usually a good idea. Note the shadows created behind the boots.

---

Canon 100-400mm IS lens, F11 at 1/30sec., Provia (without reflector)
Canon 100-400mm IS lens, F11 at 1/125 sec., Provia (with gold reflector)

Cowboy resting, Montana (without reflector)

Cowboy resting, Montana (with gold reflector)

diffuser relative to the subject is important; too high and the lighting effect is similar to a shadow cast from an opaque object. That is, the lighting is very flat and somewhat bluish. Lowering a diffuser closer to the subject bathes it in soft wraparound light with a natural color balance. Pick a subject and look through your viewfinder while moving a diffuser up and down; the changes in the lighting are clearly visible. When diffusing the light on your subject, make sure the background is completely shaded the same as your subject. Otherwise you'll end up with out-of-focus hot spots behind your subject. A second diffuser can be used to reduce contrast on sunlit areas in the background.

Even when the lighting is soft and diffused, sometimes you'll need to bounce a little extra light into dark areas. For example, the inner throat of a trumpet-shaped flower is darker than the rest of the flower. The solution is to direct soft light into the flower with a reflector. When shading a subject beneath a diffuser, don't use a reflector to kick harsh sunlit onto the subject. Make sure to reflect only soft diffused light. Otherwise, you're just adding back the shadows you wish to eliminate. You can however use a reflector to kick direct sunlight into the shadows of sunlit scenes to help reduce contrast in selected areas.

The beauty of working with diffusers and reflectors is that you can see the results before taking the picture. A basic reflector can be made from a simple white card, a mirror, or by gluing crumpled aluminum foil to a piece of cardboard. My reflectors are collapsible, with white on one side and gold on the other. This way I can reflect warmer tones when desired.

Exposure is greatly affected when altering natural light with these tools. Be sure to meter the subject after setting up any diffusers or reflectors. I don't typically use warming filters for subjects illuminated beneath a diffusing panel.

## ACCESSORIES

The realm of close-up photography is a gadget lover's paradise. It seems there is a specialized tool or gizmo for every conceivable application. Selecting the most useful tools and learning to use them can be a scary proposition for the mechanically challenged. When first starting, consider a so-called close-up filter or diopter. These simple lenses resemble a filter that threads onto the front of your lens. Attaching

a diopter to a prime lens allows much closer focus and permits high quality close-ups without owning a true macro lens. Forget single-element designs because image quality is poor, especially near the edges of the frame, and they need to be stopped down to get decent quality. Canon and Nikon make very high quality two element close-up diopters designed for use on lenses in the range of 75-300mm. These two element designs maintain high image quality without stopping down. Buy one that fits your largest diameter lens, and use step down rings for attaching it to smaller lenses.

My favorite lens to use with diopters is a 70-200mm F2.8 zoom. The magic of this combination is that once your subject is focused, you can zoom the lens for more or less magnification and the subject stays in focus. No other accessory does this, and if that isn't enough, the diopter doesn't penalize you by loosing light. The only real downside to using a diopter is that your lens no longer focuses to infinity. Instead of carrying an extra macro lens, one easily pocketed diopter can transform a zoom you already own into a useful macro lens.

Another handy device for making lenses focus closer is an extension tube. These are hollow tubes with no optics and serve as spacers between the camera body and lens. They are commonly available in various lengths from about 12mm to 100mm. The longer the tube used with any given lens, the closer that lens will focus. Extension tubes can be used to make just about any lens focus closer. Wide-angle lenses require very little extension to focus extremely close. The longer the lens, the greater the extension required for close focusing. Extension tubes don't affect optical quality, but they do cost you light and you lose infinity focus. If a slight breeze is wiggling your subject, the loss of light and resulting slower shutter speed may be a problem. In a breezy situation, a diopter that doesn't loose light, will help with faster shutter speeds. Make sure the tubes you buy maintain all the electronic connections with your camera. Your camera meter then automatically compensates as you add or subtract tubes.

When extension tubes alone won't produce an acceptable image size; or you can't physically get close enough to your subject, adding a 1.4X or 2X teleconverter provides additional image magnification. Now the question is where to add the teleconverter? You have two basic choices: either

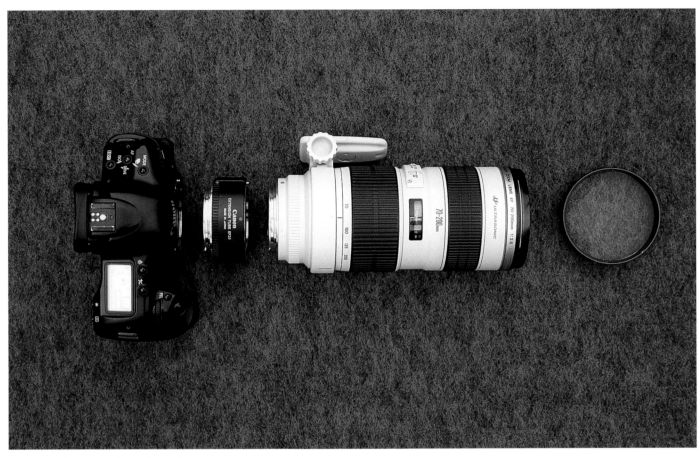

**Accessories for making lenses focus closer**

**Shown here** are the most common accessories for making lenses focus close enough for pro-quality close-ups. Pictured is a 70-200mm F2.8 zoom lens, with a 25mm extension tube located between the camera body and prime lens, and a Canon 500D close-up diopter for the front of the prime lens.

between the lens and extension tube or between the extension tube and camera body. Each combination has a different effect on working distance, magnification, and light loss. If you own extension tubes and a teleconverter, experiment with the combinations at home to develop a feel for what is possible with each combination.

When photographing small subjects at 1:1 or greater magnifications, achieving focus via the lens barrel can be very frustrating. The best method is to prefocus at roughly the desired magnification, and then move the entire camera in and out until the subject snaps into focus. Sliding a tripod-mounted camera back and forth isn't practical in the field. The solution is a focusing rail. This device allows the camera to be moved back and forth via a rack and pinion design for very precise focusing. Unfortunately, there are very few good rails available. One of the very best is model #B150 made by Really Right Stuff. For more information go to: www.reallyrightstuff.com.

**This series demonstrates** the different levels of magnification achieved when using a popular zoom lens with and without accessories. At minimum focus without accessories, magnification is quite low. Next, the addition of a 25mm extension tube increases magnification a great deal. Combining both the extension tube and Canon 500D close-up diopter yields an even greater increase in magnification.

**Film box photographed with 70-200mm F2.8 lens, at minimum focus, with no accessories**

**Film box photographed with 70-200mm F2.8 lens, minimum focus + 25mm extension tube**

**Film box photographed with 70-200mm lens, minimum focus + 25mm extension tube + close-up diopter**

**B150 precision rack & pinion focusing rail manufactured by Really Right Stuff**

**Using the lens barrel** to focus during high magnification close-up work is nearly impossible. The solution is to preset your magnification and then move the lens in and out until the subject is in focus. A quality focusing rail lets you smoothly move the camera in and out to achieve critical focus.

## USING FLASH

Natural lighting is easily my favorite light source, but sometimes it's simply too low for active subjects. Flash easily fixes the problem; however, don't start off on the wrong foot by mounting your flash in the camera hot shoe. You'll encounter two problems immediately. In a vertical orientation, a flash mounted in the hot shoe is low and angled too far from the side. Telephoto lenses create another problem for hot shoe-mounted flash by obstructing the light path between the flash and subject, resulting in underexposure and partially lit scenes. Regardless of camera orientation, the best position for your flash is few inches above the lens axis near the front of the lens. This ensures a natural angle of illumination and prevents the lens from blocking the flash. Many writers suggest positioning the flash well off axis. I strongly disagree when using a one flash set-up. Keep the flash above the lens axis.

Some sort of bracket is required to hold the flash above the lens, and an off-camera flash cord maintains electrical connection with the hot shoe. Any flash bracket worth considering should quickly and easily accommodate horizontal and vertical shooting, and allow for tilting the flash downward for very close subjects. I use a B85 flash bracket made by Really Right Stuff (www.reallyrightstuff.com) that is

**The shadows in this image** clearly indicate a flash was mounted directly over the lens and aimed downward about 30 degrees to 40 degrees. This drives the shadows down behind and below the subject simulating natural daylight. For large subjects a single flash is too harsh, but up close even a small flash unit is relatively large compared to the subject size.

Canon 180mm macro lens, F16, 1/250 sec., E100VS

**Red-eyed tree frog (captive)**

exceptional and elegantly simple for lenses equipped with a tripod collar. Wimberley (www.tripodhead.com) manufactures a modular system of macro extension arms compatible with collared and noncollared lenses. Both systems require an Arca style quick release plate.

Once your flash is mounted on a bracket, you've got a great rig for handheld close-ups of small active creatures. When handholding, select a relatively small aperture (F11–F22) and set the camera to its highest sync speed. Changing shutter speed has no effect on exposure. Even in bright sunlight, flash at close range overpowers any natural light and is essentially the only light source for the subject.

Focusing a handheld camera for close-ups can be quite challenging. Try setting the lens to the approximate magnification needed and then as you look through the viewfinder move back and forth until the subject is in focus. If more or less magnification is needed, refocus the lens and start over. Trip the shutter just as the subject comes into focus and the extremely short duration of the flash freezes any camera or subject movement.

**Small active creatures** like this jumping spider seldom remain still long enough for setting up a tripod and making natural light photos. A handheld close-up outfit with flash allows the flexibility needed to approach and compose small animated subjects. With flash, very small apertures can be selected for maximizing what precious little depth of field there is, and the flash freezes any camera movement thus ensuring razor-sharp hand-held images.

Canon 180mm macro lens, F16, 1/250 sec., full flash, E100VS

**Metaphid Jumping Spider**

Most cameras today feature through-the-lens (TTL) flash metering which automatically controls exposure by a light sensor inside the camera. I now rely totally on TTL for flashed close-ups. TTL removes the mental gymnastics required to figure exposure with manual flash or with flash meters. In this mode, I can shoot at any distance within range, add or subtract filters, teleconverters, and extension tubes, and the TTL system automatically corrects for perfect exposure. This leaves me free to concentrate on my subject and not the math required figuring exposure. Changing aperture does not control exposure. The TTL flash system automatically varies the flash output to compensate for changes in aperture. Use the flash compensation feature and dial in + or − settings to vary the output of your flash. Why override the automatic flash settings at all? Flash metering systems work just like your camera does for natural light. It wants to make everything average toned. Since all subjects aren't average, light-toned subjects require plus compensation and dark-toned subjects need minus compensation. The exact amount will vary depending on the subject's relative lightness or darkness and size within the frame. It takes a few test rolls to get a feel for the way your system handles light and dark subjects, but the tests will help fine tune your TTL exposures.

**This elegantly simple flash bracket** by Really Right Stuff is ideal for positioning a flash off camera for close-up photos. The flash is automatically mounted in the correct position above the lens for illumination that appears natural, and the head on the bracket tilts so the flash can be aimed downward for very close subjects.

**Close-up flash bracket.**

**Mining bee on coneflower (full flash)**

**Close-ups with flash** are especially prone to rapid light falloff. For example, the bee in this full flash example is surrounded with black because flash can't reach a background just a few feet behind the subject. The result is an unnatural image appearing to have been made at night. Compare the same scene using a slow shutter speed for correct natural light exposure and fill flash set at -2 stops. Now the bee and the background both have correct exposure for more pleasing results. This same fill flash technique is especially effective with flower close-ups.

Canon 180mm macro lens, F16, 1/250 sec., full flash, E100VS.

Canon 180mm macro lens, F16, 1/8 sec., fill flash, E100VS.

**Mining bee on coneflower (fill flash)**

# 10

# MOTION

## PANNING

Panning refers to taking a picture while moving the camera to follow a subject in motion. The idea is to track the subject as it passes perpendicular to you and continue following it during the exposure. This technique is used for action subjects like running horses, race cars, and wildlife. The basic idea is to impart a sense of motion by rendering the subject fairly sharp while blurring the background. A relatively slow shutter speed is used so the background blurs as the camera follows a moving subject. Notice I said relatively slow. Panning can be very unpredictable. A shutter speed of $1/15$ second is about right for running horses while $\frac{1}{60}$ second might be better for automobiles traveling around a track at 230 mph. The amount of blur on the background and parts of the subject will vary widely depending on shutter speed and panning speed. Panning a running horse at $\frac{1}{15}$ second blurs the background and some moving parts (feet and legs) of the horse. The blurry legs and feet add a sense of action and movement.

The point is, you need to experiment with different shutter speeds. As a starting point, try using shutter speeds between $\frac{1}{8}$ to $\frac{1}{60}$ second. The trick is choosing a shutter speed slow enough to blur the background, but not to where tracking the subject is impossible. The viewfinder goes blank when you press the shutter so follow through and continue the swing of the camera even though you can't see your subject. Proper technique is to uncoil your body smoothly, swiveling at the waist as you follow the subject in motion. To render the subject sharply, match your tracking speed with that of the subject.

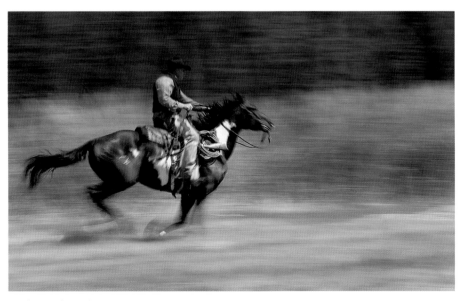

Cowboy on horse in Montana

**This is a very traditional use** of panning. A relatively slow shutter speed combined with a telephoto lens provides just the right amount of subject sharpness and blurry background for illustrating movement. Canon's 100-400mm IS lens set for pan mode, eliminated any up and down jerks for a smooth handheld pan.

Canon 100-400mm IS lens, F16, 1/15 sec. +polarizing filter, E100VS

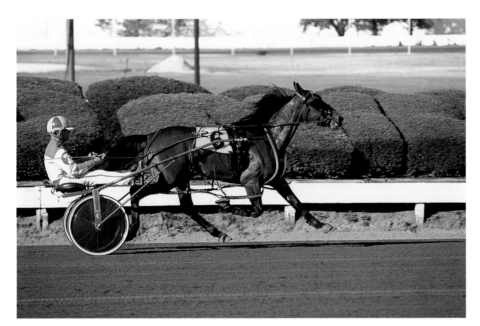

Harness racing, Turfway Park, Florence, KY (without polarizing filter)

**Stopping a subject** dead in its tracks with a fast shutter speed isn't always the best for action images. In this first image I panned at $1/500$ second, which froze all the action. The image is static, the horse and jockey don't appear to be moving in relation to the background. Next, panning with a $1/15$-second-shutter speed allowed the background to streak and emphasized the movement of the horse's legs. Now the horse and jockey appear to be flying past the background. A polarizing filter was used to help reduce shutter speed for the slowest pan shot.

Canon 100-400mm IS lens, F5.6, 1/500 sec., E100VS

Canon 100-400mm IS lens, F16, 1/15 sec., polarizing filter, E100VS

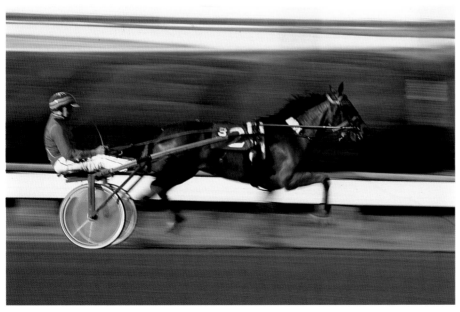

Harness racing, Turfway Park, Florence, KY (with polarizing filter)

Unwanted up and down camera movement can be a problem when panning a telephoto lens. The slightest jerk can ruin a panned image. Panning from a tripod eliminates most of this problem. Wimberley manufactures gimbal style tripod heads that offer unparalleled freedom of movement when panning a heavy lens from a tripod. When handholding a camera, the latest image stabilized lenses from Canon and Nikon provide tracking modes that do a good job of eliminating most up and down movements while allowing you to pan left or right.

Even though the results are unpredictable, with practice you can perfect this technique. Practice with different shutter speeds and focal lengths until you develop a feel for the results.

## STOP ACTION

From a purely mechanical standpoint stopping action is fairly easy. Simply choose a wide open or nearly wide open aperture with moderate speed film to get the fastest shutter speed possible. Depending on the situation, typical action-stopping shutter speeds range from around $1/250 - 1/1000$ second with moderate speed film. Fast lenses are useful for several reasons. They allow faster shutter speeds that enhance your ability to freeze faster moving subjects. In a given situation, a larger aperture permits the use of slower, finer-grained film and helps separate the subject from the surroundings. A motor drive isn't absolutely mandatory, but most serious stop-action photos are made with motor drive equipped cameras.

From a practical standpoint, there is more to consider. Weather it's wildlife or a sporting event you need to know your subject. Great action shots are seldom the result of luck. Decide ahead of time where to position yourself for the best action. Many sporting events have very predictable actions. During a basketball game you know the scoring action is going to take place at the goals on opposite ends of the court. Most wildlife exhibits some kind of predictable behavior just before it takes to action. Understanding the timing of these predictable actions allows you to anticipate the peak moment. Stopping action is all about timing and reacting. Anticipating the action is everything. If you wait till you see the action, you've missed it. Even with the best reflexes, there is a delay in our reactions. Then another delay occurs as the mirror swings up in the camera. Capturing the decisive moment requires tripping the shutter a few milliseconds before the event actually happens. You can be in the right place at the right time but the action is gone if you don't anticipate it happening.

Using high shutter speeds to freeze the subject has one downside: it can arrest the movement so well the image appears static. Again, timing is critical. Your aim is to capture the decisive moment, when the action is most dynamic.

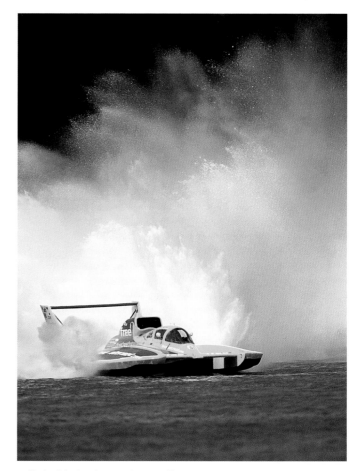

**Unlimited hydroplane racing, Madison Regatta, IN**

**Knowing the layout** of this racing event I selected a position where the racers were making a difficult high-speed turn. The boats were moving their slowest upon exiting the turn. The action was dramatic and predictable. A fast shutter speed stopped the boat completely but the dynamic spray of the water says speed and drama. Diagonal positioning of the boat implies movement across the frame.

Canon 500mm IS lens, + 1.4X teleconverter, F5.6, 1/1000 sec., E100VS

Action advancing toward or away from the camera requires less shutter speed than action moving perpendicular to the camera. The latest autofocus cameras are quite capable of tracking moving subjects. If your autofocus isn't fast enough, prefocus your lens to where you expect the action to occur. Remember to anticipate and trip the shutter just before the subject hits the prefocused area.

**Kayaker in rapids, Merced River near Yosemite National Park, CA**

**After being completely submerged,** this colorful kayaker was captured just as he popped back to the surface. This action was repeated several times in the same spot, so anticipating the action was relatively easy. The shutter was activated the instant I saw the tip of his kayak break the surface. As you can see the peak action was caught a few milliseconds later. Timing and reaction are critical to stop-action photos.

Canon 100-400mm IS lens, handheld, F5.6, 1/500 sec., E100VS

**Lesser flamingos running on Lake Nakuru, Kenya**

**Knowing your subject** always helps make you a better photographer. Stopping action is no exception. These two birds were part of a flock of nearly a million flamingos. Recognizing their signs of agitation and knowing they prefer taking off into the wind allowed me to anticipate and react as they started running. A wide-open aperture was used with Provia pushed 1 stop to ensure a fast shutter speed.

Canon 400mm F2.8 lens + 2X teleconverter, F5.6, 1/500 sec., Provia pushed 1 stop.

## MOTION EFFECTS

The most commonly practiced technique employs a slow shutter speed as all or parts of a scene move while the camera is motionless on a tripod. Stationary elements of the scene remain tack sharp while movement is recorded as a streak or blur. This strategy is very effective with waterfalls and streams, where stationary parts of the landscape record sharply and the water blurs as it flows through the frame during a relatively long exposure.

Another way to imply motion is to zoom a variable focal length lens while the shutter is open. Even stationary

subjects seem to explode with motion. Begin by setting your lens at the wide end of the zoom range. During the time the shutter is open, zoom the lens to its longest focal length. Slow shutter speeds work best because it's difficult timing the zoom with faster shutter speeds. With a little practice, you'll find speeds at or below ⅕ second fairly easy to time. The zoom effect radiates out from the center of the picture, so keep the subject reasonably centered. A bit of coordination helps with this hit-or-miss technique. Keep experimenting if your initial results are disappointing.

Another motion effect is simply a variation on panning

**Baby giraffes running, Masai Mara, Kenya**

**A sharp image** of the giraffes is not the desired result for this impressionistic view. The most important quality of this image is the sense of dynamic motion and flowing rhythm. This effect was achieved by panning with the running giraffes using a short telephoto lens during a ½-second exposure.

Canon 100-400mm IS lens, F16, 1/2 sec., E100VS

where abnormally slow shutter speeds are panned. Traditionally, the idea is to capture a moving subject relatively sharp against a streaking background. For an impressionistic interpretation you don't want the subject tack sharp. Dramatic motion images can be quite blurry, but retaining enough shape for subject recognition. The idea is to capture a dynamic flow of movement and shape. Panning with shutter speeds in the range of $1/4$ to 1 second is typical. The results are very unpredictable, but that's part of the fun in experimenting with this technique.

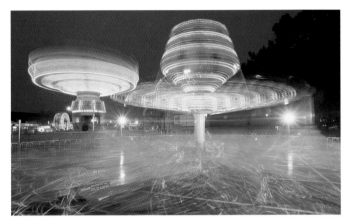

Amusement ride in motion, Kentucky State Fair, Louisville, KY

**Here a traditional approach** is applied to a nonnature subject. The camera is still while some parts of the machinery are in motion and others are stationary. Lights on the ride created an unusual pattern of streaking color, contrasting with stationary objects.

Canon 17-35mm F2.8 lens, F11, 1 minute, Velvia

Zoom motion, Kentucky Horse Park, Lexington, KY

Cascade and moss-covered rocks, Great Smoky Mountains, TN

**This is a traditional method** of recording movement in a landscape image. A tripod-mounted camera and a 6-second exposure allowed the flowing water time to move through the image. The rocks and moss are tack sharp and the cascading water records as a flowing blur through the image.

Canon 90mm tilt/dhift, F16, 6 sec. + warm polarizing filter, Velvia

**Here I rapidly zoomed** from 28mm to about 70mm during a slow $1/15$ sec. exposure to create this dynamic explosion of color. The technique is simple, but timing the zoom and shutter is tricky at best. The results are very hit or miss. In this case I got very lucky!

Canon 28-135mm IS lens, F22, 1/15 sec., Velvia

# NATURE AND WILDLIFE

## SELECTING AND USING TELEPHOTO LENSES

Making an informed decision when buying a quality telephoto lens is important; it can easily be the single most expensive piece of equipment most of us ever purchase. The first question to ask is, what kind of wildlife do you intend to photograph? If you plan to seriously photograph birds, a 500mm or 600mm lens is a good choice, but for relatively tame deer and elk in national parks a 300mm lens may provide the necessary image size. In most cases there is no substitute for focal length and lens speed. Up to a point, longer and faster is better. Wildlife is often much farther away than we think, and it's surprising how close you need to be for an effective photograph. For example, a northern cardinal can only be 10 feet away for full-frame image with a 400mm lens. Now the question is, can you get that close? I'm not a fan of high-speed 300mm F2.8 lenses as a workhorse optic for wildlife. They are great lenses, but too short for all but the largest wildlife and you end up using teleconverters for nearly every shot. Even 500mm and 600mm lenses often need a teleconverter when photographing smaller subjects. For serious wildlife photography consider lenses in the 400mm to 600mm range.

The next question is how fast a lens do you need. In the field you need all the light you can get. The extra light improves manual focusing and the ability to freeze moving subjects, and also minimizes the effects of camera shake. Unfortunately, price and weight increase dramatically as lens speed increases. For example, a Canon 400mm F5.6 weighs 2.75 pounds and costs about $1,100 while the 2 stop faster Canon 400mm F2.8 weighs 13 pounds and sets you back about $7,000. Only you can decide if the extra speed and performance is worth the extra cost and weight. Buy the very best you can afford and the fastest lens you'll carry into the field. A fast premium quality telephoto lets you add 1.4X or 2X teleconverters giving you the versatility of three high-quality lenses in one. Another point to consider is that commercial airlines are getting more restrictive concerning the size and weight of carry on baggage. My Canon 500mm F4 IS lens weighing about 8 pounds is a great compromise in focal length, weight, and speed. It easily packs into a Lowepro Photo Trekker backpack that is airline legal.

When considering any telephoto lens, make sure to check its minimum focusing distance. The closer the lens can focus the better. Adding extension tubes permits closer focus, but in doing so, you lose light and effectively reduce the speed of your lens. Another priority feature is internal focus. This means focus is achieved through lens elements moving inside the lens barrel. An internal focus design doesn't grow physically longer as it focuses closer; therefore no light is lost. An F4 lens remains an F4 lens regardless of where it is focused. Thankfully, most modern telephotos now feature internal focusing.

I have strong feelings about telephoto lenses and autofocus. Don't buy a telephoto lens without autofocus and also strongly consider image stabilization if offered by your camera manufacturer. This technology permits razor sharp images from a tripod at substantially slower shutter speeds than conventional designs. Imagine working with a 500mm lens and a 2X teleconverter at speeds as slow as $1/15$ and $1/30$ with very sharp and repeatable results. In some circumstances, I've even made professional quality images handholding an image stabilized 500mm F4 lens with a 1.4X teleconverter attached. This type of performance is impossible without IS technology.

Good technique is especially critical when using a long

Canon 100-400mm IS lens at 100mm, F8, 1/125 sec., E100VS

Canon 100-400mm IS lens at 200mm, F8, 1/125 sec., E100VS

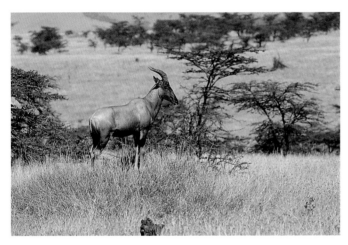

Canon 100-400mm IS lens at 300mm, F8, 1/125 sec., E100VS

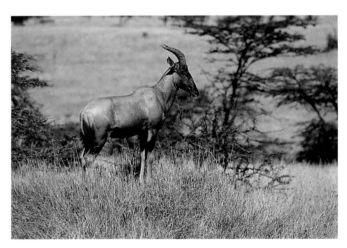

Canon 100-400mm IS lens at 400mm, F8, 1/125 sec., E100VS

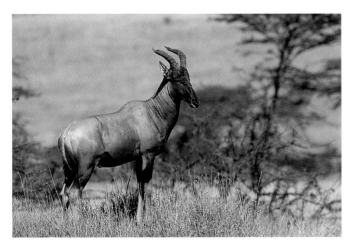

Canon 500mm F4 IS lens, F8, 1/125 sec., E100VS

**This series clearly demonstrates** how focal lengths from 100mm to 500mm produce varying image size from a fixed point approximately 150 feet from the subject. At 100mm and 200mm, the topi is just too far away and the angle of view encompasses way too much hazy sky. At 300mm the angle of view is reduced just enough to crop out the sky and this focal length begins to isolate the subject. Of course, at 400mm and 500mm the subject is larger; most distractions are significantly reduced, and our cooperative Topi now has impact.

**Topi, Masai Mara, Kenya**

lens. A sturdy tripod and head is necessary for nearly every shot. Blurry images are common because telephotos magnify vibrations. To minimize this problem, use wide-open apertures to ensure fast shutter speeds for stopping any subject or camera movement. For scenics or static subjects, use a cable release and lock the mirror up to reduce vibration from mirror slap. In my opinion, ball heads are a terrible choice for large, heavy lenses. You're constantly wrestling with floppy unstable top-heavy lenses. Wimberley offers gimbal-type tripod heads that completely solve this problem. For more information go to www.tripodhead.com.

## BACKYARD ADVENTURES

Everyone wants to shoot in some exotic locale, but how often can you afford to be off travelling in some far-flung destination? It's great fun, but the truth is that a lot depends on luck. You can do plenty of research in preparation, but success is sometimes determined solely by the whims of nature. Once I spent a week on location where it rained hard, all day every day. The moral is you pay your money and take your chances. Sometimes we need to remind ourselves of the advantages of working subjects much closer to home.

The key is developing an inquisitive attitude and looking for the wonder in common, everyday subjects. You'll be surprised at the number of opportunities right in your own backyard. Spend time studying the daily routine of whatever wildlife is attracted to your yard. I'll bet there is more going on than first meets the eye. Look closely, and you'll discover the favorite branch where a humming bird repeatedly perches or where a robin is secretly building her nest.

The greatest advantage of working close to home is that you're already on location when conditions are perfect. You can afford to be patient, waiting until the light and mood are just right and within minutes you're outside reaping the benefits. Your backyard is the perfect place to hone your skills. It's terribly frustrating to be in an exotic location knowing that you're missing opportunities while still learning what works and what doesn't. I learned to photograph birds in my backyard. Now I use those very same skills to photograph birds and other wildlife around the world. I also perfected my close-up techniques on flowers and insects in my yard. If you enjoy small close-up subjects, the inquisitive photographer can find an endless supply just about anywhere.

**Taking the garbage out** one morning, I was surprised by the interplay of sunlight through the trees and mist. I ran back in the house to get my camera and tripod for a quick shot before the scene vanished. My yard isn't normally scenic in any way, but once in a great while, the elements conspire to create a magical scene just outside my back door.

---

**Sunbeams streaming through trees.**

Canon 28-135mm IS lens, F16, 1/60 sec., Velvia

All backyards are not created equal. Some need a little help by planting trees and bushes for cover, and flowers for attracting insects and wildlife. Flowers are great subjects themselves, but they also afford additional opportunities for subjects such as bees, butterflies, skippers, and hummingbirds. Plant flowers that bloom throughout the year for an

**We rightly associate** large mammal photography with large wilderness areas, but many urban subdivisions support higher concentrations of small mammals than do natural areas. Depending on where you live, squirrels, rabbits, chipmunks, and groundhogs are abundant and easily baited to your yard. This gray squirrel was enticed into position with sunflower seeds placed in a crack along the top of the log. Put out food in the same place over several days and small wildlife habitually return looking for an easy meal.

**Gray squirrel.**

Canon 100-400mm IS lens, F8, 1/125 sec., Velvia

**Just about any yard** will attract birds once food is consistently made available. Study your surroundings first; figure out when the lighting works for your intended subject. In this image, a heavily frequented bird feeder was taken from its normal location and placed at the base of a small tree to entice birds to perch where I wanted. This image was made from a blind on an overcast afternoon when the subject and background were both in the same soft light.

**Blue Jay in backyard setting**

Canon 500mm F4 IS lens, F4, 1/30 sec. + fill flash at −1-2/3 stops, E100VS

**Butterflies** and other insects are easily attracted to summer flowers such as coneflowers, butterfly bush, and black-eyed Susans. Select flowers with varying bloom times and you'll have willing subjects all summer long. Flash instantly freezes these highly animated subjects, but getting the film plane parallel to a small moving subject will test your skill and patience. A backyard setting is a great place to develop and perfect your close-up skills.

**Silvery Crescentspot butterfly on cone flower.**

Canon 180mm macro lens, F16, 1/250 sec., full flash, (handheld) Velvia

ever-changing colorful landscape. Consider a small water feature or pond for attracting frogs, dragonflies, and birds. I keep several feeders stocked with seeds for attracting a year-round supply of avian subjects. Don't photograph birds on the feeder, but use the food to attract them to suitable locations or perches that you set up.

If your backyard is totally unsuitable for photos, become familiar with nearby wood lots, ponds, and parks for interesting subjects. I consider abandoned fields and wood lots within five to ten minutes of my home as part of my extended photographic backyard. These locations close to home allow me the luxury of conveniently returning many times and seeing the location a new way each time. Enlist the help of neighbors; ask them to alert you when they see opportunities in the neighborhood. I'm forever indebted to several neighbors who have directed me to snakes, fox dens, and bird nests that I would have otherwise missed. I'm always amazed by the fact that my single best selling image was taken just five minutes from my home.

## STALKING & USING BLINDS

Knowledge of your subject is far and away the best asset for getting close to wildlife. The more you know about a subject, the better your chances of getting close enough for pictures. Most of the techniques are common sense, but even so, practice improves your technique. Armed with keen senses and an uncanny sense of survival, wildlife has the advantage in the field. Remaining hidden and sneaking up on wary subjects is nearly impossible, so I usually make no attempt to conceal my approach.

The trick is slowly closing the distance without causing the subject to feel threatened. Stay low and approach in a slow zigzag manner. The biggest mistake is hurrying toward the animal in a straight line. Don't rush to get close; take plenty of time and let the subject acclimate to your presence. Watch where you are stepping. It is easy to stumble and accidentally scare your subject. Avoid direct eye contact; this is considered threatening. View the subject's reactions using your peripheral vision. You want to appear casual and

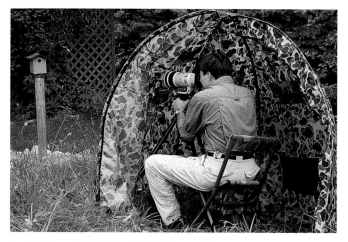

**Rue blind used for backyard bird photography**

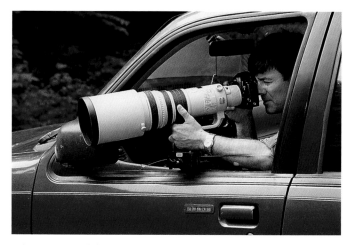

**Using an automobile as a mobile blind**

**This blind** fans out from a collapsed position into a free-standing enclosure in about 30 seconds and is fully ready to use in minutes. Four guylines are provided for windy conditions or if the blind is to be left up. This is an excellent blind when set up on relatively level ground.

**It's surprising** how often wildlife along roadways have little or no fear of an automobile, but step out of the vehicle and the wildlife often departs rapidly. When traveling, I always keep a camera mounted on a telephoto lens for those unexpected encounters. A beanbag or window mount is good for supporting lenses from inside an automobile. Turn the engine off and coast into shooting position.

uninterested in the subject. If the animal stops what it's doing and appears nervous, simply stop and wait for it to resume normal activity. Resume your approach once the animal appears unconcerned. Mammals have a strong sense of smell, so work from a down wind position.

Keep your gear to a minimum when stalking. Have your telephoto lens and camera mounted on a tripod ready for action. Preset exposure and other camera functions when possible. Make sure you have plenty of film in case the subject cooperates far better than imagined. Take a few shots en route to your desired position just in case the animal flees. Set your gear up slowly and deliberately; any fast moves can ruin an otherwise successful stalk.

A blind or hide is another option for observing and photographing wildlife up close. Now the strategy is concealment. The strategy is to be in the blind well before the wildlife appears. Choosing a good location requires prior knowledge of where animals are likely to appear or baiting them within range. Baiting is the most consistent method and that's exactly what I do with feeding stations for birds. When photographing birds, I like to have someone follow me out to the blind and stand there while I'm getting in. Once I'm settled in with my gear the decoy person goes away and the birds quickly resume their normal activities. Birds can't count so they don't realize one person is still inside the blind.

After spending many hours in a blind you'll learn that patience is your greatest asset. Your equipment should be mounted on a tripod with the lens positioned through an opening in the blind. You can't possibly hold the camera still waiting for a subject to arrive. Keep all movement inside the blind to a minimum, including your gear. Don't swing your lens around quickly to frame an approaching subject. Move slowly and deliberately. Make sure no part of the blind is flapping in the wind. Work from a blind is best done when it's relatively cool and shaded. Sunny summer days send temperatures skyrocketing inside a blind, and you running for an air conditioner.

I've used a Rue Ultimate Photo Blind for years and found it to be excellent. It is easily transported, durable, and sets up in about 30 seconds. For more information go to www.rue.com.

Your car is an excellent mobile blind when shooting in state and national parks that prohibit traditional blinds. Most wildlife don't view an automobile as a threat and often allow a close approach. Turn the engine off before stopping and coast into position. With a beanbag propped on the window ledge of your car you are ready to shoot. I also use a modified Kirk Window Mount by Kirk Enterprises that provides steady support from a vehicle. For more information go to www.kirkphoto.com.

**Male eastern bluebird bringing food to nest cavity**

**I set up** this potential nest cavity as bait and successfully attracted a pair of nesting bluebirds. Concealed in a Rue Blind, it was easy to observe and photograph both parents without disturbing them as they brought an assortment of insects and small lizards to their young.

## ON SAFARI

The media often paint a dismal picture of widespread war, disease, and crime in Africa. For travelers on safari this is a bum rap. Traveling in Kenya is safe, comfortable, and relatively easy. I've had the good fortune of leading several photo safaris to Kenya and we've always shared some unbelievable spectacles of nature. No other place on earth rivals east Africa for sheer diversity and easy access to wildlife.

The first priority is making sure the safari you choose is designed to meet your photo objectives. Many safaris are listed as photo tours but are definitely not set up for serious filming. I always use the same outfitter who provides four-wheel drive Land Rovers driven by highly experienced professional driver/guides. Our driver/guides are unbelievable at finding game and know the terrain so we don't get lost. I prefer to keep the same driver/guide for the entire trip. The skill and personality of your driver has a huge impact on the success of any safari. Absolutely know for sure how many people will be in each vehicle. The fewer the better. It's a luxury, but the limit is three photographers per vehicle on my safaris. This way each photographer has a roof hatch to shoot from and the windows below on either side of the vehicle. This way you are not missing opportunities waiting for your turn to photograph.

Seasons in east Africa are mainly classified as rainy or dry seasons. Americans typically travel during June, July, and August, which are the driest and coolest months in Kenya. October through December is the time of the short rains, which is also excellent and less crowded. March through May is the rainy season, and a safari at this time can be very unpredictable. Plan for at least a two-week trip, three if you have the time. On a two-week safari, limit your itinerary to three parks, otherwise you lose too much time driving between locations. My favorite itinerary includes Samburu National Reserve, Lake Nakuru National Park, and world-famous Masai Mara. Spend about three nights in Samburu,

Driver/guide David Kariithi Ngunyi, Masai Mara, Kenya

Land Rover accommodating three photographers, Masai Mara, Kenya

**Here my favorite guide,** David Ngunyi, enjoys a lighthearted moment with a cheetah using our hood as a hunting lookout. Your guide's personality and skill in finding game have an enormous impact on your enjoyment, education, and photo success. Look for a safari led by a skilled photographer who enjoys working with people and uses only the best drivers/guides who understand and cater to the needs of serious photographers.

Canon 28-135mm IS lens, F11, 1/125sec. + flash balanced for exposure outside vehicle, Provia pushed 1 stop

**In this photo** three participants are comfortably photographing a lion kill from atop one side of our vehicle. As you can see, limiting the vehicle to three people ensures that everyone has an unobstructed view of the action at all times. Don't consider any safari that claims to be designed for photographers if they allow more than three people per vehicle. Selecting a safari that provides the right vehicle with the right number of people is critical.

Canon 100-400mm IS lens, F8, 1/250 sec., E100VS

two nights in Nakuru, and the rest in the Masai Mara. If staying for three weeks consider adding Amboseli to your safari or spend another entire week in the Mara.

Never go to a remote location without a backup camera or two. You never know when something might fail. A motor drive is recommended because there is plenty of action. Bring extra camera batteries and film. First-timers are always shocked at the amount of film they shoot and the number of batteries consumed. Bring plenty of both, and if you have extra, you can always use these items upon your return home. With moderate-to-fast lenses, a good fine-grained ISO 100 film suffices for most situations.

As far as lenses go, a 300mm is the bare minimum as your primary wildlife lens. For dramatic portraits, 400-600mm lenses are usually ideal and even these often require 1.4X or 2X teleconverters. Nearly all filming is done from inside your safari vehicle, so tripods are mainly used for shooting small animals and birds around our camp. A simple beanbag is inexpensive and excellent for supporting telephoto lenses atop your vehicle. Long lens technique dictates open apertures and fast shutter speeds for stopping active subjects and vehicle wiggle.

Pack light, because weight restrictions for in-country flights are very tight. Enough underwear for a week and a few shirts and pairs of pants are the basics. Along with your personal toiletries, also bring a sweatshirt because morning drives are cool enough to see your breath. A sun hat is a good idea since the top of the vehicle is open all day. Once you have your passport and shots for malaria and hepatitis, you are ready to embark on a life-altering adventure.

I would like to say thanks to all of those who have accompanied me on my safaris and to drivers David, Albanus, and Enoch for their help and expertise in making our game drives some of the most enjoyable and memorable of my life.

For information on my tours to Kenya please visit, www.adamjonesphoto.com

**Photographer using beanbag to support 500mm lens, Masai Mara, Kenya**

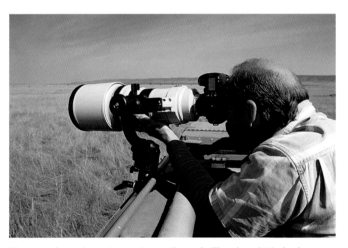

**Photographer using a Bogen Super Clamp, ballhead, and Wimberley Sidekick to support 400mm lens, Masai Mara, Kenya**

**These two images** illustrate two excellent but different methods for supporting a telephoto lens while on safari. An empty beanbag is lightweight, requires minimal space when packing, and is easily filled with beans or rice upon arrival. Since it's not attached to anything, a beanbag allows for nearly instant readiness. The downside is they are not great for panning with active wildlife. A ballhead fitted with a Wimberley Sidekick and clamped to the vehicle requires a few more seconds to set up, but once in place, is hard to beat. With this rig, panning active mammals and flying birds is a snap. Your lens is perfectly balanced, virtually weightless, and if you accidentally let go of your lens it won't go crashing to the ground.

## ZOO PHOTOGRAPHY

I frequently visit the zoo in my hometown and always inquire about zoos, butterfly exhibits, and aquariums when traveling to other cities. This country is blessed with many fine zoos offering excellent photo opportunities. Many photographers thumb their noses at the suggestion of photographing captive animals. That's fine. They'll just miss some great photo opportunities. As a beginner, the zoo is a great place to sharpen your long lens techniques and if you are a pro, the zoo offers access to endangered species nearly impossible to photograph in the wild.

My zoo photography usually falls into one of two basic categories: large outdoor exhibits lit with natural light and close-ups of small creatures housed behind glass or wires. Indoor exhibits behind glass usually require full flash for lighting, while butterfly houses and walk through aviaries may only need fill flash. Bright overcast lighting is ideal for outdoor exhibits. Direct morning and afternoon sunlight is great when you can find an exhibit where shadows don't ruin the setting. I usually recommend avoiding exhibits in partial sun and shade. Depending on your objectives most outdoor exhibits require a long telephoto lens. A long lens lets you concentrate on details and tight portraits, thus avoiding any signs of the enclosure, bars, wires, and concrete rocks that scream zoo shot. Sometimes a 300-400mm lens is plenty and other times a 500mm lens with a 2X teleconverter is too short. If you can live with a few man-made objects, a shorter lens will do nicely.

Without a doubt there are plenty of obstacles to work around in most zoos. The biggest offenders are the wires and fences separating us from the animals. Believe it or not, it's possible to shoot right through some wires and fences. The strategy is to keep your lens as close as possible to the wire or fence and shoot with a wide-open aperture for shallow depth of field. Select subjects as far behind the wire or fence as possible. That way your subject is in sharp focus beyond the obstruction, which in turn renders the obstruction invisible or nearly so. It's nearly impossible to blur out fences and wires when the subject is right next to it. Fences and wires directly in front of your lens should be shaded if they are in bright sunlight. Avoid shooting through small chain link fences; they're nearly impossible to eliminate.

Numerous times a well-meaning zoo visitor has informed me that using flash to illuminate a subject behind glass was a mistake. No doubt this person tried and got a nasty reflection off the glass. Getting around this situation is embarrassingly simple. When shooting through glass, position your lens close to and perpendicular to the glass surface. Shooting at a steep angle through glass degrades image sharpness. Do not mount your flash in the camera hot shoe. Instead use an accessory off-camera cord with the flash

**Gaboon viper behind glass, St. Louis Zoo, St. Louis, MO**

**Shots of exotic** and, in some cases, potentially dangerous species are as close as your local zoo. This gaboon viper, known for possessing the largest fangs in the world, was safely and easily photographed behind glass in the reptile house at the St. Louis Zoo.

Canon 180mm macro lens at F16, 1/250 sec., full flash, E100VS

Wrong way to photograph through glass, Louisville Zoo, Louisville, K.

**Here the photographer** is making two very basic mistakes. First, the camera and flash are too far away from the glass and the flash is mounted in the camera hot shoe. Either of these mistakes alone is enough to cause a glare on the glass, but in combination they practically guarantee failure.

Right way to photograph through glass, Louisville Zoo, Louisville, KY

**This image illustrates** the correct method for shooting through glass. Here the flash is positioned flush with the end of the lens via a Really Right Stuff flash bracket, allowing the flash to be tilted downward as needed for close-up subjects. Here the photographer correctly positioned the lens and flash against the glass. As long as the glass is clean, it will be invisible in the final picture. If you don't own a flash bracket, you or an assistant can hold the flash against the glass, but doing so is more cumbersome.

positioned near the glass a few inches above the lens. Light from the flash should be striking the glass at an angle above the lens. This bounces any reflections away from the lens. Remember that the angle of incidence equals the angle of reflectance. Since many zoos don't permit tripod use indoors, flash is the perfect answer for handheld images of frogs, insects, spiders, and fish behind glass. Please be cour-

teous to other zoo patrons at all times and don't allow your tripod to restrict access in any way. Each zoo has its own unique photo opportunities: don't attempt to shoot every exhibit. Each zoo has a few really photo-friendly outdoor exhibits. Forget the impossible exhibits. Be selective and spend your time at the best exhibits and your patience will be rewarded.

**Several important conditions** were met to make this an ideal situation for shooting through a wire enclosure. First, the subject is positioned about ten feet beyond the enclosure, which means that when a telephoto lens is focused on the stork, the wires are so out of focus they are virtually invisible. Secondly, the exhibit layout permitted a telephoto lens to be placed 2 ft. from the wires. The closer your lens is to the wires the better. Sunlit wires are more likely to degrade your image quality, so either work when it's overcast as in this example or shade the wires from direct sunlight.

**European stork on nest, Brookfield Zoo, Chicago, IL**

Canon 500mm F4 IS lens at F4, 1/60 sec., E100VS

**In this example** I simply refocused the lens to make the wires visible.

**European stork on nest. Brookfield Zoo, Chicago, IL.**

Canon 500mm F4 IS lens at F4, 1/60 sec., E100VS

**Female Bonobo or pygmy chimpanzee, Columbus Zoo, Columbus, OH**

**This endangered species** is difficult and expensive to photograph in the wild. The outdoor enclosure at the Columbus Zoo provides a wonderful setting that allows access to an endangered species without putting additional pressures on a species in decline. A long telephoto lens isolates the subject and the surroundings appear natural.

Canon 500mm F4 IS lens, at F4, 1/125 sec., E100VS

# DIGITAL PHOTOGRAPHY

## SELECTING & USING DIGITAL CAMERAS

The advances in digital imaging keep arriving fast and furiously. Hardly a month goes by without the introduction of another new advancement promising a standard in quality. Keeping up with changing technology and making an informed decision on the right digital camera can be quite confusing.

The first step is deciding how you plan to use your digital camera. If all you want to make are tiny prints and share your pictures over the Web, then just about any camera will do. For serious imaging of subject matter such as sports, wildlife, and for making large prints, you'll need a fairly sophisticated model. Choose a camera that offers sufficient resolution for your intended output. The number of pixels contained in a camera's image sensor is a very important factor in determining a camera's ability to record fine details. Maximum resolution is expressed in megapixels (one million pixels), which commonly range from about 3 on the low end to about 12 on high-end professional models. For most serious hobbyists a 4-6 megapixel camera provides plenty of resolution for inkjet prints up to 13" x 19". In general the larger your camera's megapixel count, the more flexibility you have when making enlargements. The problem is that one manufacturer's 6-megapixel camera may not capture the same fine detail as another. Before buying any digital camera make some test photos and run them through your workflow to make sure the results are what you need. Some cameras use interpolation to invent pixels in order to achieve a higher megapixel. Look for one that offers true resolution without interpolating.

Fortunately, today most digital cameras offer fairly accurate color, but there are differences in color relating to noise, richness, and color transitions. Large differences are visible from one manufacturer to another and there are even some surprising differences within some brands from one model to another. There are two main considerations when comparing color. You definitely want a camera that lets you choose the color space used by the camera to process the digital image. Many cameras offer only sRGB, which has a narrow range of colors. For the best possible color, look for a camera that offers a wide gamut color space like Adobe RGB. More advanced cameras have well thought out and full-featured white balance controls, allowing easy correction of color casts under a wide range of lighting. Ideally you want presets for correcting common lighting types such as tungsten, fluorescent, and overcast lighting. The best cameras offer automatic and fully customizable white balance control for eliminating unwanted color casts.

Look for the same features in a digital camera that you find desirable in a film camera. Many of the performance features commonly found on intermediate-level film cameras are missing on all but high-end digital cameras. Mid-priced cameras usually don't feature the quickest and most accurate auto-focusing systems, which could be a major consideration when shooting sports or fast moving subjects. Most feature a capture rate of about three frames per second, which is slower than their film counterparts. For most situations this is fast enough, but when a faster capture rate is needed, an advanced-amateur or professional-level camera may be the only option. Another action-related issue worth considering is shutter lag, which is the delay between when the shutter is pressed and the image is taken. Nearly all but the top models have a longer delay time than equivalent film cameras. If action photos are your forte, look for a pro-level camera with minimal shutter lag. The total number of frames a camera can record in one sequence also varies widely between camera models and manufacturers.

If you are new to digital cameras, the extra controls not found on film cameras may be intimidating at first. A well-designed layout of buttons, and easy to navigate on-screen menus can make a camera much more enjoyable to use and easier to learn. Major features to look for are full control of in-camera sharpening, saturation, contrast, and other image processing parameters. A bright, sharp LCD screen is desirable for reviewing your results on location. One of the most important features is a histogram that indicates when highlights are overexposed. This feature is the only reasonable way to judge exposure on location when not attached to a computer. Some sort of easy-to-use interface should be provided for white balance adjustment.

All digital cameras have built in computers that convert the raw image data into a recognizable file such as JPEG or TIFF. Most cameras include a RAW setting that turns off the in-camera processing and instead sends the picture data directly to the card with no image processing. In the raw format it is possible to correct for color balance and exposure mistakes after the fact in some software. This allows for great flexibility in image correction, but the downside is the huge amount of time involved in correcting and converting large quantities of images. It's far better to make sure the scene is white balanced and exposed correctly in the first place so you can enjoy taking pictures instead of spending hours in front of a computer fixing mistakes.

Using a digital camera is very much the same as a film camera as far as technique is concerned. Hobbyists switching from print film to digital need to learn that digital capture requires very precise exposure much like slide films. The temptation is to get sloppy with exposure, thinking it can always be fixed later in Photoshop. Small errors can indeed be fixed, but once the highlights are just slightly overexposed, they are lost and cannot be restored with any software.

Digital cameras are completely dependent upon electrical power; they have quite an appetite for power and quickly exhaust batteries. A fast battery charger can help ensure that fresh batteries are always on hand. Once the space on your removable storage media is filled with pictures, you must download the images into another storage device or put in a fresh media card. Spare cards are not cheap, but it's a good idea to have several handy so you can keep shooting instead of waiting for images to download to another device. Don't be foolish: back up important images

on CDs or some other form of removable storage device. It's just a matter of time until your computer crashes and if not backed up, your valuable images may be lost forever.

Nearly every digital camera features an image sensor smaller than 35mm film, which means that every lens attached to a digital camera undergoes a magnification increase. The increased magnification is usually a factor of 1.3X to 1.6X which usually isn't a problem when shooting with telephoto lenses where the increased focal length is welcome. The down side is that even ultra wide-angle lenses loose much of their effectiveness when used with a digital camera. At the time of this writing, only the Canon EOS 1Ds ($8000) and the Kodak DCS Pro 14n ($4500) offer full-size chips which don't increase focal length.

## BASIC ADJUSTMENTS TO THE DIGITAL IMAGE

One of the most exciting aspects of digital photography is that once an image is digitized, it can be saved as is, gently tweaked to perfection, or manipulated it into something completely new and different. Depending on your creativity and level of expertise using image-editing software, you now have unprecedented control of the creative process. Far and away the most widely used image editing software is Adobe Photoshop, which has tons of filters, functions, and professional features. The nearly unlimited number of options can be confusing and make this program a bear to learn and even more difficult to master. It's expensive and the learning curve is indeed steep, but if you take the time to learn it, you'll own a powerful image-editing program that you're not likely to outgrow. Photoshop Elements is less expensive and easier to learn for those who can live without all the bells and whistles and need only to make basic adjustments.

Whether from digital capture or scanned film, the first step after importing an image into Photoshop is to review the histogram. This is accessed by going to the main pull down menu under Image > Adjustments > Levels. You'll see a black-and-white graph representing the tonal values of your image. Ideally you want to see values spread across the graph starting just inside the left triangle (dark tones) then peak in the middle, and then taper down to just inside the right triangle (highlights). The middle triangle represents

the mid-tone values of the image. A well-exposed digital capture or film scan should fall between the sliding triangles at both ends of the histogram. If the information on the graph appears to go off the right end, the image is overexposed; if the information appears to go beyond the left end, then the image is underexposed. Assuming you are correctly exposed, it's possible no adjustment may be needed. Most images, however, benefit greatly by pulling the left sliding triangle to the right until it meets the shadow information on the graph, and then pulling the right triangle to the left until it meets the highlight information on the graph. Once both the shadow and highlight adjustments have been made, tweak the mid-tone sliding triangle to fine-tune the overall exposure to your liking.

## PRO TIP

Before applying levels adjustments, first convert the image from 8 bit mode to 16 bit mode by going to Image > Mode > 16 bits per channel. Adjust levels as described previously and then convert back to 8 bits per channel to continue working in Photoshop. Novice users often select the Brightness/Contrast sliders for what appears to be a similar effect, but this method lightens or darkens every pixel in the photo, whereas, Levels permits selective adjustment where needed.

Once Levels is properly adjusted, the next step is to remove any dust spots or scratches. If the image sensor on your camera is perfectly clean, then no dust spotting is required. Scanned film on the other hand always needs to have dust spots removed. Some scanners offer routines that automatically remove dust and scratches; however, this feature also softens the overall image slightly. For the ultimate in quality, leave automatic dust spotting turned off, and manually dust spot as needed in your image editing software. To begin, enlarge the view size of your image to 100 percent so you can concentrate on small areas. On Macintosh computers hold down the Apple Key + Spacebar and click on the image. Windows-based computers accomplish the same by holding down the Control Key

+ Spacebar. While holding down the appropriate keys, each mouse click causes the image to progressively enlarge until reaching 100 percent. Photoshop displays the zoom ratio as a percentage value in the title bar. It's important to realize that any image imperfections visible on your monitor at 100 percent will also be visible when printed.

Once an image is sufficiently enlarged, scroll across every square inch of the photo looking for dust spots, scratches, or any other imperfections. The Clone Stamp Tool often referred to as the Rubber Stamp Tool is invaluable for cloning out imperfections and is accessed by clicking on its icon in Photoshop's tool bar palette. Once the tool is selected, move your brush over the area in your picture you wish to clone from and Alt+click (PC) or Option+Click (Macintosh). Then move your brush to the problem area and paint over it with the area defined by clicking. Adjust brush size according to the area to be cloned and remember that you can change cloning opacity to aid blending in difficult areas. In most situations, cloning with a soft edged brush lets the cloned area blend seamlessly into the existing area.

## PRO TIP

Many images benefit greatly from adjustments to color, density, and contrast, but these adjustments should not be made directly to the image. Adjustments made directly to the image destroy color information and further adjustments made at a later date only destroy more information. The best way to make adjustments is by using Adjustment Layers. From the main menu, go to Layer > New Adjustment Layer. An adjustment layer is like placing a colored gel or neutral density filter over the image and looking through it. The big benefit of an adjustment layer is that it doesn't degrade pixel information and it gives you the ability to change your adjustments later. Numerous adjustment layers can be added to a single image and turned on and off or re-adjusted and your original image remains unchanged.

Original scan, Chicago skyline, Chicago, IL

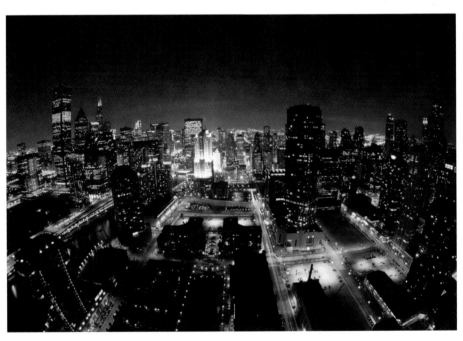

Color-corrected original scan, Chicago skyline, Chicago, IL

**The original scan** is a bit flat and overall color balance needs adjusting. The first step is to review the original Levels histogram from the main pull down menu under Image > Adjustments > Levels. Next we'll adjust the slider triangles for optimum contrast. Next we'll add an adjustment layer to correct color balance. From the main pull down menu go to Layer > New Adjustment Layer > Selective Color. A small window opens. Here you simply check the box next to "Group With Previous Layer" and click OK. Next, a Selective Color Option window opens. Under Colors, select Neutrals, and then slide the Magenta slider bar 16 percent to the right and click OK. Now the color balance is vastly improved without degrading the original color information. In the Layers palate the adjustment layer is shown above the original background layer. An adjustment layer can be turned on or off as many times as desired or readjusted without harming the original color information.

Canon 15mm fisheye lens, F8, 30 sec., Velvia

## STORING AND SAVING DIGITAL FILES

The good news is that the quality of digital imaging just keeps getting better. Unfortunately, true photographic quality requires rather large file sizes. A 5x7 at 300dpi is a 9 MB file and an 8x10 at 300dpi is a 20 MB file. These file sizes are still easily stored on your hard drive, but you need a way to move files from one computer to another and to others such as your print lab.

## ZIP DISCS

The now-outdated floppy disc which stores about 1.4mb of information is totally inadequate for storing quality images. To be useful, much larger capacity is needed in a portable storage device. Zip discs were introduced in 1995 in response to the increased demand for larger removable storage. About the same size as a floppy, they gained wide acceptance from photographers and graphic professionals. Currently zip discs are available in 100 MB and 250 MB capacities and cost about $10 and $15 respectively. A zip can be written and rewritten as often as necessary, which makes it ideal for incremental backup of important works in progress. However, don't use this proprietary format for archiving important images. Zip discs are probably due for extinction, and this will create significant problems down the road.

## CD-ROM

When it comes to storing massive amounts of information cheaply, the CD-ROM is king. This very stable format is now universally accepted to the point that most new computers are fully equipped to read and write standard CDs. Some older computers with read only drives need to be updated with a CD burner before you can write your own CDs. Currently, two formats are available. The most common and least expensive is the CD-R. Once a certain portion of the CD is written it cannot be rewritten. However, most software allows the CD to be written in multiple sessions; that is, you can write one amount of data and then later add additional data until the disc is full. The most advanced version is a CD-RW which permits the disc to be rewritten many times. These are more expensive than standard CDs and the writing times are much longer. Some experts feel there may be some long-term archival issues with heavily rewritten CD-RW discs. Costing about 50¢ cents each, most professionals archive their finished files on the standard CD that holds up to 700 MB of information.

## DVD

Digital Versatile Disk or DVD is rapidly gaining popularity. This is most likely going to be the preferred method of storage in the very near future as more and more computers are shipped with DVD reading and writing capability. This format offers more options and can store the equivalent of 6 regular CDs in the space of one DVD disc. Currently, everyone isn't set up to handle this format and each disc is about $4. At the time of this writing, the industry has not settled on a standard DVD format. If and when a standard is set, this technology will solve a lot of problems.

Regardless of the format used, consider these two important tips. Always, always, always back up every important file. Make two copies of every important image. Keep one backup file at home and a second copy off premises in the event of a disaster. It's very unlikely that both copies would ever fail to read properly. Keep up with changing technology so you can rearchive your images before the format they are stored on becomes obsolete and unreadable.

No matter how large a hard drive we own, it always seems to fill up in short order. To help save space on your hard drive, save your digital images using the TIFF format with compression turned on. Don't worry, the compression in this format does not degrade the quality of your images in any way. Start organizing your digital files now. They can quickly become disorganized which results in difficulty locating images and creates duplicate images that waste space.

Once a file is downloaded from your camera and worked on, it's time to save your hard work. At this point Photoshop makes you pick a file format in which to save your image. The main compression formats used throughout the world are JPEG (Joint Photographer's Expert Group) and TIFF (Tagged Image File Format)

JPEG uses a lossy algorithm for maximum space-saving compression of your images. Unfortunately this format compresses by removing information which can never be recovered, therefore, degrading image quality. When downloading a JPEG original into your computer, it should be "saved as" into a lossless format such as TIFF. Do not use JPEG as your editing format because each time you do a "save as" your image will suffer additional loss of information. If you need a

JPEG file later for image transmission or for use on the Web, you can always convert from another format.

TIFF format is a lossless image format; that is, no pixels are removed from the image. TIFF files have the option of being compressed using a technique known as LZW, which reduces image size with no loss of information. A compressed TIFF file is still rather large and definitely larger than JPEG files. Obviously, this format should be your first choice for archiving or sharing work when the highest quality is needed. Photographers favor TIFF since it was an early standard on Macintosh computers and is compatible with CMYK color information.

PSD files are a proprietary format that supports layers within Photoshop. This format is fine for archiving your files, but when sharing files with others, some programs and machines do not support this format. When sharing layered files, convert them to layered TIFF files for greater compatibility with different programs and output devices. When working with layered files in Photoshop, always archive the image with all the layers; do not flatten the image. Flattening the image saves space on your hard drive, but you loose the tremendous flexibility of working on individual layers at a later date.

If you haven't already done so, now is the time to get your digital files organized and archived properly. Storing large numbers on images on your hard drive slows your computer's performance and is risky for important photos. Act now, your computer hard drive is like a ticking time bomb working its way to an inevitable crash. Make sure all

your valuable images are backed up on CDs or DVDs and don't forget to make a second copy for storage off premises. There are two kinds of people in this world: those that back up their files and those wishing they had backed up important files.

## DESKTOP PRINTING

Now the moment of truth has arrived. You've worked for hours at the computer creating your digital masterpiece. You're ready to print, so you cross your fingers and send the file to the printer. If the print matches the image on your monitor, consider yourself lucky. Unfortunately, many digital photographers struggle with the realities of getting their inkjet prints to match their monitors.

Working with a color-calibrated monitor is crucial for consistent results. Fortunately, Photoshop ships with a control panel "wizard" that allows you to do a basic visual calibration of your monitor and create an ICC profile. To access this procedure go to, Control Panels > Adobe Gamma. In the window that opens, check the Step-By-Step (Assistant) and follow the simple procedure. At the end of this procedure you'll save your newly created monitor profile. Next you open the Color Sync control panel (Mac) or the Display control panel (on a PC) and select the new profile as your monitor profile. Color-managed programs will now automatically use this monitor profile to convert colors for viewing. A visual calibration can get you in the ballpark, but for truly accurate profiles, you need a colorimeter

**Storage media**

**Shown here** is a 700 MB CD-R and 700 MB CD-RW, a 4.6GB DVD, and a 100 MB zip disc. The standard 700 MB CD-R is the most widely used media for transferring data between machines and archiving images. At the time of this writing a standard format has not been established for DVDs, which makes them less desirable for long-term archival storage. Zip discs can be rewritten as often as necessary, which makes them ideal for incremental backup.

that attaches to the front of your monitor and measures the actual color phosphors. The hardware and calibrating software for these devices usually cost about $400.

The next step is making sure Photoshop's Color Preferences are set correctly. While in Photoshop go to the main pull down menu under Edit > Color Settings. Select Adobe RGB 1998 as your working RGB color space. This wide gamut color space is perfect with all inkjet printers using color management such as Epson, Canon, and others. This is all that's needed for Photoshop to manage color. The rest of the settings shown in the Color Settings menu are worth setting as well.

Now that Photoshop and your monitor are communicating correctly, it's time to print. Some of the steps outlined here are specific to commonly used Epson inkjet printers; however, the basic strategy applies to other printers as well. Depending upon model and brand printer, you'll encounter several windows along the way with different menu options. One of the first options is paper choice; make sure you select the paper you are using. Along the way you must set printer resolution and dithering settings, which vary depending on the paper used and amount of detail in your picture.

The most important step is turning off the printer's color management so Photoshop can color manage your images. Look for the advanced settings in the Color Management window within your printer software and choose No Color Management. Stay away from your printer's color controls such as Automatic, Photo Realistic, and Vivid. Once No Color Adjustment is selected, then make sure you have the right paper profile selected. When encountering a choice for rendering intent, select Perceptual. Using these settings and a properly calibrated monitor, your first print should be fairly close. However, generic profiles provided by the printer manufacturer often leave a great deal to be desired. In reality some tweaking of the print is still likely.

At this point you're either happy with the results or they are off just a bit. If your prints are consistently too light, too dark, or too red for example, you can work around this mismatch by adding temporary adjustment layers to the file. Unfortunately, this is still a hit or miss proposition often requiring several attempts to get a perfect print. For truly accurate prints, consider purchasing a custom profile for your printer. You'll receive a profiling test target consisting of some 200–300 color swatches. You then print this target with your desired media/ink combination, and mail your print to the profiler who measures it and creates a custom profile for your system. This defines the unique color gamut of your devices. With custom profiles, prints should match your monitor very closely. This process must be repeated for each type of paper used. A good custom profile will easily pay for itself in saved paper and ink. Good sources for custom profiles are Nancy Scans (www.nancyscans.com), Outback Photo (www.outbackphoto.com/profiling_service/profiling.html), and Inkjet Mall (www.inkjetmall.com).

When scanning a slide or negative for printing, scan large, because the file can always be scaled down for smaller prints. Avoid scaling images up (interpolating). I always scan my images at the highest resolution (4000 dpi) setting on my film scanner. By doing so, I get all the information and detail from the slide. This creates about a 55 MB file good for enlargements up to 12" x 18" printed at 300 dpi without interpolating. This same file can be easily scaled down for smaller prints. Most inkjet printers now boast a maximum resolution of about 1440 ppi, but this rating does not correlate with dpi when printing. Your inkjet printer only needs a 300 dpi file. Print quality does not improve by sending files to the printer with resolutions higher than 300 dpi. Images are easily scaled to size in Photoshop's main menu under Image > Image Size. When resizing an image, check the Constrain Proportions box to keep image proportions the same. The Resample Image box should only be checked when interpolating an image to a larger size or when scaling a large file down to make a smaller print. Select bicubic from the pull down menu for the method of resampling. Under document size you have boxes for inputting Width, Height, and Resolution. This is where images should be sized for printing.

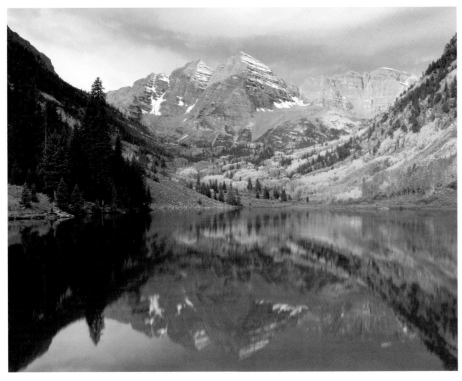

**Maroon bells at sunrise (Automatic Mode)**

**Working from a color-calibrated monitor,** the first image was made with my Epson 1280 set in Automatic Mode. The image is off-color and less saturated than the view on my monitor. The next image was made with No Color Adjustment selected in my printer's color management software. With this setting the image is now very accurate.

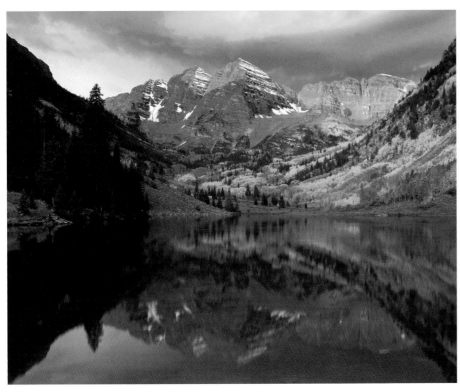

**Maroon bells at sunrise (No Color Adjustment)**

# INDEX

# THE BEST IN PHOTOGRAPHY GUIDES

## ARE FROM WRITER'S DIGEST BOOKS AND DAVID & CHARLES!

### Creative Techniques for Photographing Children
Capture the magic of childhood with Vik Orenstein's technical and creative advice. You'll learn to create great compositions and master perspective, manipulate light to evoke mood, work with interesting visuals, and master lenses, film, processing, printing and more. Nine professional portraiture projects provide the detailed advice and step-by-step instruction you need to photograph children like a pro. You'll also find additional guidance on running a successful photography business and the digital revolution.

*ISBN 1-58297-028-9, paperback, 160 pages, #10712-K*

### Photo Portfolio Success
Pulitzer Prize-winner John Kaplan shows you how to edit to your strengths and prepare a stunning portfolio-one that wins over editors, buyers and contest judges alike. You'll find genre-specific advice from experts in nature, commercial, advertising, fashion, fine art, wedding, and photojournalism. Hands-on examples from top photographers and inside advice from leading agents will give you an important edge that can land your portfolio on top of the stack.

*ISBN 1-58297-210-9, paperback, 160 pages, #10861-K*

### Digital Photography Handbook
Tim Daly details the basics of digital photography. This clear, jargon free approach gives you a working understanding of the equipment, software and techniques you need to create amazing digital images. More than 50 creative techniques are explained step-by-step including basic adjustments, advanced special effects, using software such as Photoshop and more.

*ISBN 0-89879-945-7, paperback, 160 pages, #10643-K*

### Photographer's Market
This must-have reference provides photographers with more than 2,000 completely updated market listings with contact information for magazines, stock agencies, advertising firms, book publishers, greeting card and poster markets, newspapers, businesses, and galleries. You'll also find a fantastic selection of helpful articles and "Insider Reports," plus information on contests, workshops, professional organizations and more.

*ISBN 1-58297-186-2, paperback, 632 pages, #10924-K*

### Photos with Impact
Learn how to view any subject, compose a picture and take the best image possible with this helpful guide. Author Tom Mackie describes how you can learn to see subjects you might otherwise miss and learn how to simplify images down to their basic elements. He also addresses how an understanding of the basic rules of composition is crucial to successful image-making and subsequently, how breaking these rules can also create striking, modern compositions. You'll find practical instruction on composition, lighting, color and form, filters and digital photography to create more impact in your photos.

*ISBN 0-7153-1506-4, paperback, 144 pages, #41563-K*

### 100 Ways to Take Better Photographs
This essential and informative book is for everyone who wants to improve their photography skills. Inside, readers will find answers to many of the most common questions amateur photographers ask. In a clear, jargon-free style, Michael Busselle provides solutions that will help both beginners and more advanced photographers get the picture results they want, whether they shoot on film or digitally. You'll find advice on photographing interiors and taking portraits as well as special close-up techniques for photographing wildlife or pets, bringing a fresh eye to architectural shots and how to best shoot a landscape view in all types of weather.

*ISBN 0-7153-1499-8, paperback, 128 pages, #41557-K*

### The Complete Guide to Beauty & Glamour Photography
In this beautifully illustrated guide, Jon Gray explores the techniques and the aesthetics of glamour photography, creating a book that is both informative and a joy to look through. Covering everything you need to know from easy-to-replicate studio poses and lighting setups to exotic locations, this book is guaranteed to give your photography a creative edge.

*ISBN 0-7153-1405-X, paperback, 144 pages, #41424-K*

### Sell & Re-Sell Your Photos, Fifth Edition
This popular guide includes up-to-the-minute information on digital photography's place in business, selling online, and the shake-up in stock and royalty-free photography. You'll find all of the information you need to market, present and sell your photos as well as tasks, charts and sidebars for help you focus on your goals and improve your profit picture.

*ISBN 1-58297-176-5, paperback, 368 pages, #10838-K*

Find these and other great Writer's Digest Books and David & Charles titles from your local photography retailer, bookstore, online supplier or by calling 1-800-448-0915.